The 1950s
Ireland in Pictures

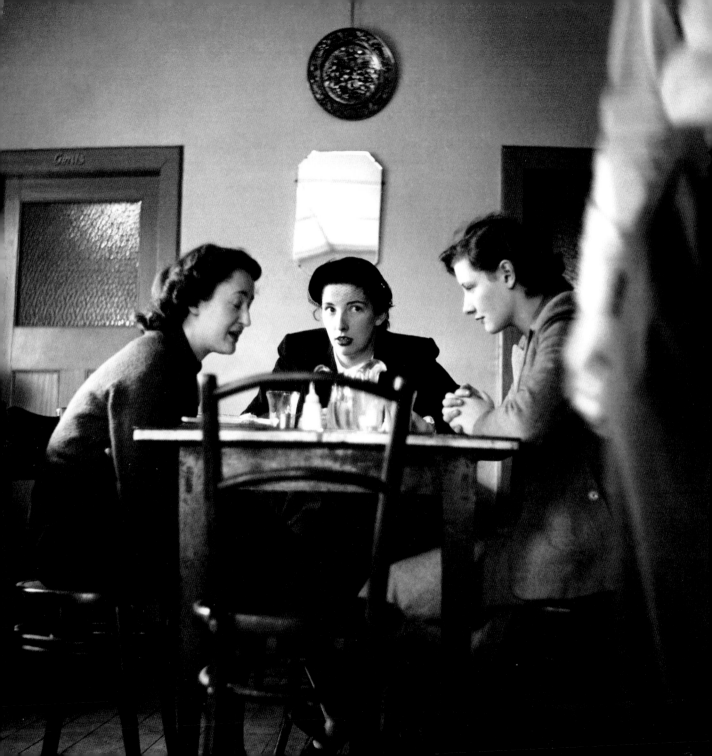

The 1950s
Ireland in Pictures

Lensmen Photographic Archive

THE O'BRIEN PRESS
DUBLIN

Opposite
Afternoon tea in Castlebar. Rita Quinn, neé
Hughes (centre) and Frances Hughes (right)
having tea in the Green Bay Cafe on the mall
in Castlebar with a friend after a journey to
Dublin where both sisters were working as
chemists. They didn't realise the photo was
being taken. Rita still has her shop on Main
Street, Castlebar and Frances is retired from
being a locum pharmacist at Mayo General
hospital.
(Information supplied by Aoibhinn Ní
Shúilleabháin)

14 October 1952

First published 2012 by The O'Brien Press Ltd.,
12 Terenure Road East, Rathgar,
Dublin 6, Ireland.
Tel: +353 1 4923333; Fax: +353 1 4922777
E-mail: books@obrien.ie
Website: www.obrien.ie
Reprinted 2013

ISBN: 978-1-84717-319-5

17 Nottingham St., North Strand, Dublin 3, Ireland. Tel: +353 1 8197738
Email: info@lensmen.ie Websites: www.lensmen.ie, www.irishphotoarchive.ie

Typesetting, editing, layout, design © The O'Brien Press Ltd
Caption research by Tara Keown. Additional caption research and editing Mary
Webb, The O'Brien Press.

2 3 4 5 6
13 14 15 16 17

Printed and bound by GraphyCEMS
The paper used in this book is produced using pulp from managed forests

Acknowledgements: It would not have been possible to put this book together
without the help of the following: Susan Kennedy, Sean Walsh, Tara Keown, Jill
Quigley, Lydia Diaz Navarro, Eleanor Keegan, Sarah Knopp, Johanna Korbik,
Judith Lutz, Ross O'Brien, Michael O'Neill, Mark Siggins.
Special thanks to Tom Ryan, Ryan International Corporation and Mary Patricia
Gallagher.

Opposite
Mickser Reid buys a ticket for the
panto at the Olympia Theatre.
Reid was a very popular actor who
regularly starred in shows in the
Theatre Royal and subsequently in
the Olympia. He also had a number
of film roles.

11 December 1952

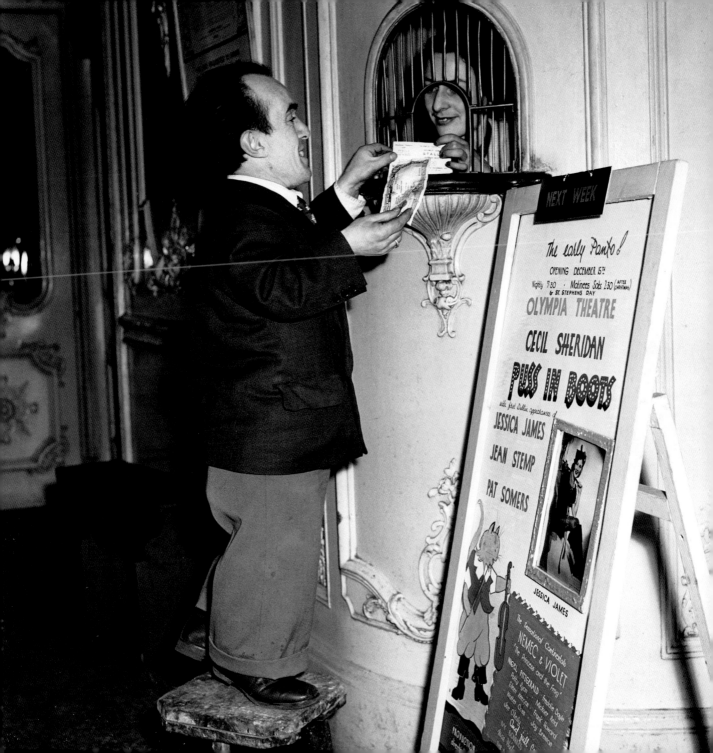

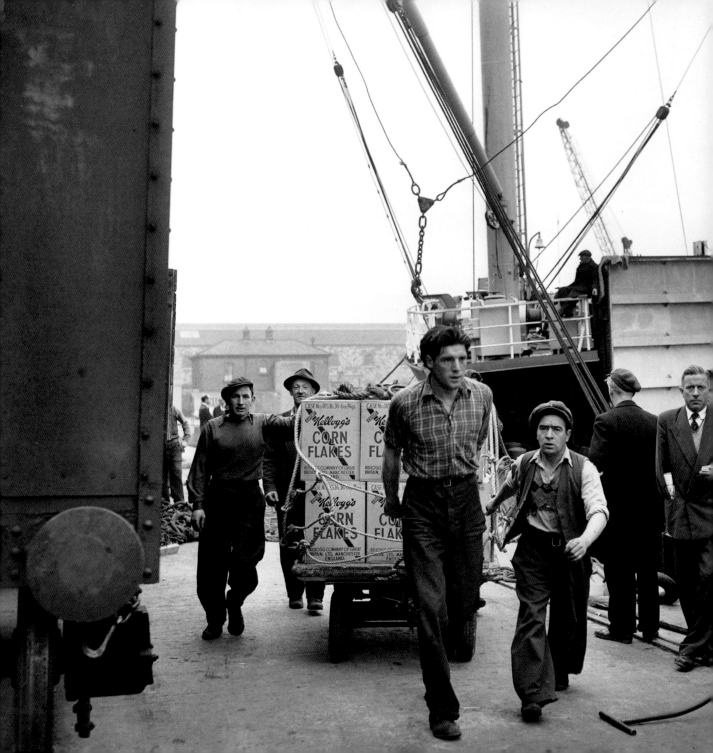

Dockers unloading a cargo of Kellogg's
Cornflakes at the North Wall, Dublin.

4 June 1954

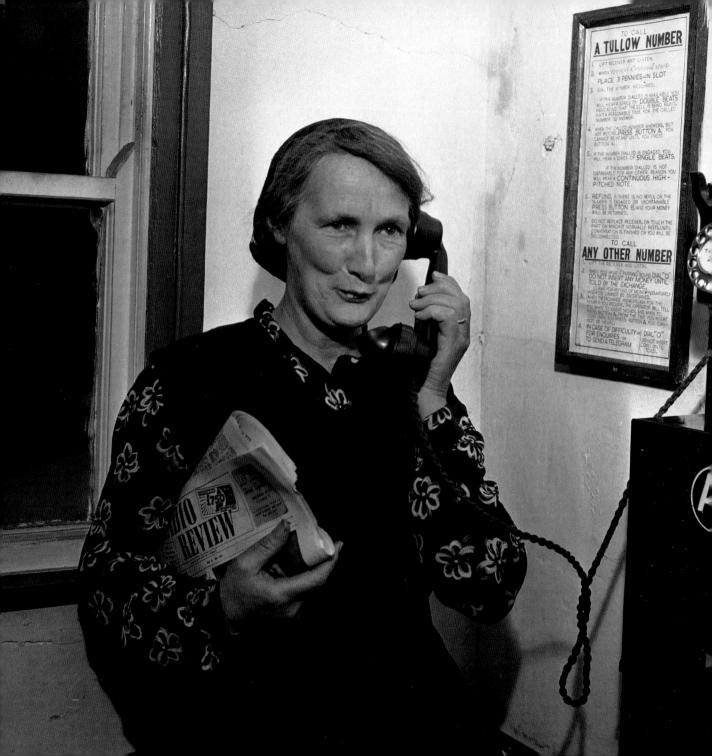

TO CALL
A TULLOW NUMBER

1. LIFT RECEIVER AND LISTEN.
2. WHEN YOU HEAR A "PURRING" SOUND.
 PLACE 3 PENNIES IN SLOT
3. DIAL THE NUMBER REQUIRED.

 IF THE NUMBER DIALLED IS AVAILABLE YOU
 WILL HEAR A SERIES OF DOUBLE BEATS
 INDICATING THAT THE BELL IS BEING RUNG.
 WAIT A REASONABLE TIME FOR THE CALLED
 NUMBER TO ANSWER.
4. WHEN THE CALLED NUMBER ANSWERS, BUT
 NOT BEFORE, PRESS BUTTON A. YOU
 CANNOT BE HEARD UNTIL YOU PRESS
 BUTTON A.
5. IF THE NUMBER DIALLED IS ENGAGED, YOU
 WILL HEAR A SERIES OF SINGLE BEATS.

 IF THE NUMBER DIALLED IS NOT
 OBTAINABLE FOR ANY OTHER REASON YOU
 WILL HEAR A CONTINUOUS HIGH -
 PITCHED NOTE.
6. REFUND. IF THERE IS NO REPLY, OR THE
 NUMBER IS ENGAGED OR UNOBTAINABLE
 PRESS BUTTON B AND YOUR MONEY
 WILL BE RETURNED.
7. DO NOT REPLACE RECEIVER, OR TOUCH THE
 PART ON WHICH IT NORMALLY RESTS, UNTIL
 CONVERSATION IS FINISHED OR YOU WILL BE
 DISCONNECTED.

TO CALL
ANY OTHER NUMBER

1. LIFT THE RECEIVER AND LISTEN.
2. WHEN YOU HEAR A "PURRING" SOUND, DIAL "O"
 DO NOT INSERT ANY MONEY UNTIL
 TOLD BY THE EXCHANGE.
 CLAIMS FOR REFUND OF MONEY PREMATURELY
 INSERTED CANNOT BE ENTERTAINED.
3. WHEN THE EXCHANGE ANSWERS ASK FOR THE
 NUMBER YOU REQUIRE. THE OPERATOR WILL TELL
 YOU WHEN TO INSERT MONEY, AND WHEN TO
 PRESS BUTTON A. FROM THE TIME YOU INSERT
 MONEY UNTIL YOU PRESS BUTTON A YOU CAN-
 NOT BE HEARD.
4. IN CASE OF DIFFICULTY OR DIAL "O"
 FOR ENQUIRIES OR
 TO SEND A TELEGRAM
 DO NOT INSERT
 COINS UNTIL
 TOLD.

The Fifties

Simpler times, yes, when children were let out to play and told to be home by teatime; when games were marbles, skipping, hopscotch, and hours could be happily passed noting the registrations of the infrequent cars that passed through rural towns, always hoping for an RIP reg from Kilkenny or a SIN from Kerry.

Frugal times, too, when 'pre-worn' or 'vintage' were just hand-me-downs, and frayed knitted cardigans and jumpers were unravelled to make new, smaller garments. Socks were darned and elbows patched, and the concept of 'leisure clothes' didn't exist. For most men, there was the 'good suit' for Sunday Mass and special occasions, and the rest of the time a mismatched old suit jacket and pants, with the occasional checked shirt in the 'parcel from America' that was a common feature, especially at Christmas.

No fridge freezers, dishwashers, washing machines, showers, made for long, labour-intensive days in houses that were often occupied by large families.

And, of course, no TV, but we did have our first radio soap, 'The Kennedys of Castleross', which began on Radio Éireann in 1955 with a cast that included Marie Kean and T P McKenna. And we had the inimitable Micheál Ó hEithir to keep us up with every clash of the ash, every pull of the jersey. And not just for GAA, as he became a staple of the BBC's coverage of the Aintree Grand National.

Wages were poor, work hard to come by. 'Permanent and pensionable' were the most desired job elements, and with most school-leavers finishing their education at Leaving Cert level or below, and no college qualifications, the boat to England was the only option for many.

Unemployment marches were frequent, with 'work, not dole' being the watchcry.

Church and State control was all too evident in Irish lives in the Fifties. The Censorship Board banned almost 100 publications for being indecent or obscene, including Behan's *Borstal Boy*. Dr Noel Browne's Mother and Child Scheme was dropped after pressure from the Church. Despite this, allegiance to Catholic doctrine was steadfast and 30,000 marched through Dublin city in a huge Marian Year procession in 1954.

But we were beginning to look outwards – in 1955 Ireland was admitted to the United Nations. And then, in 1956, a new light shone on us all from sunny Melbourne when our very own Ronnie Delany won the gold medal in the 1500 metres event at the Summer Olympics. In a crushing final sprint, he passed out his rivals and breasted the tape in a time of 3.41.2.

In 1959 Eamon de Valera became our third President, a position he retained until his retirement at the age of 90. Also in that year the first twelve female recruits were selected to join An Garda Síochána. They passed out of the training depot on 4 December. Maybe the first small steps towards the future Mná na hÉireann!

Were they happier times, better times? Certainly interesting times.

For those who remember the Fifties, we hope these glimpses of home, town, rural, sporting, big and little events, commonplace and quirky, will evoke fond memories. If you weren't around then, ask someone who was. Remember, every picture tells a story.

Mary Webb, Editor

Opposite
Making a telephone call was a complicated business in the Fifties. You had to press button A to be connected, and button B to get your money back (3 pennies for a local call). Most calls had to go through an operator.

2 August 1953

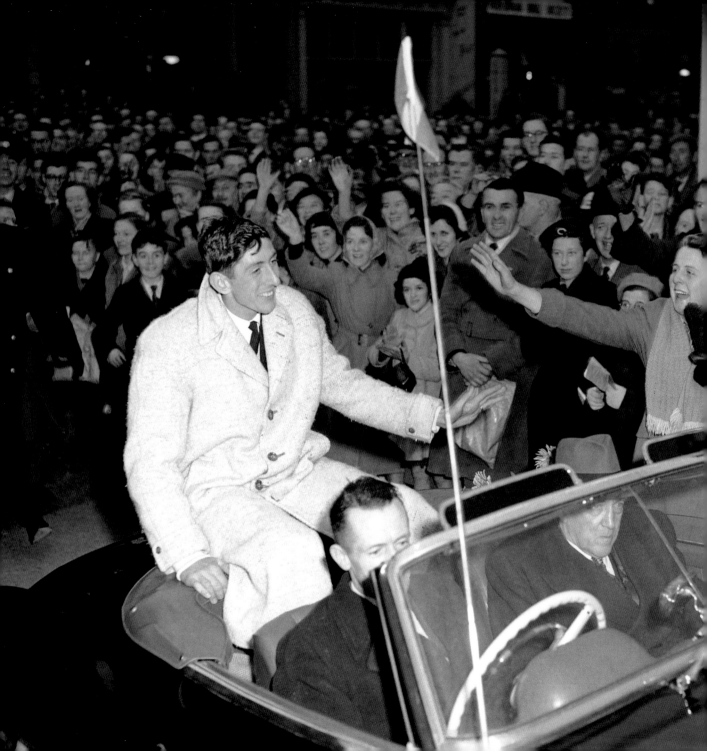

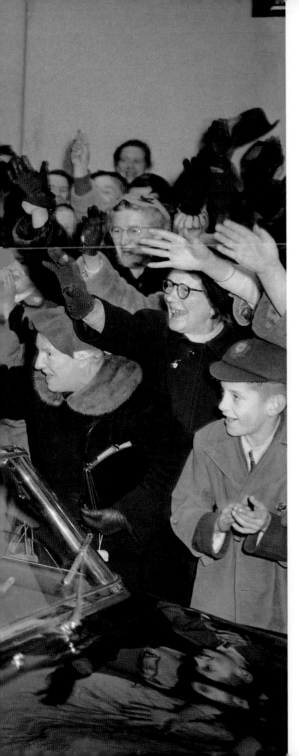

Hero of the decade. Ronnie Delany returns home in triumph
following his gold medal win in the Summer Olympics in
Melbourne. Delany won the 1500 metres final, held on Saturday,
1 December, in a new Olympic record time of 3:41:2, beating the
home favourite John Landy into third spot.

19 December 1956.

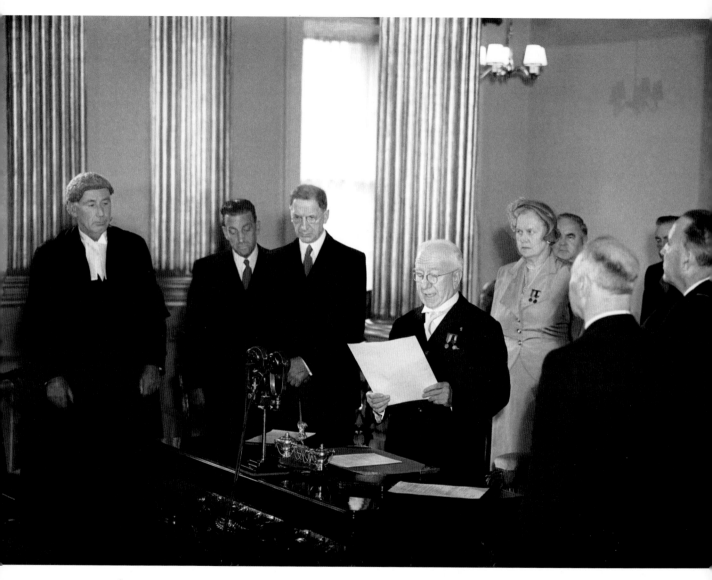

Seán T Ó Ceallaigh is sworn in for his second term as President of Ireland, watched over by
Eamon de Valera and Seán Lemass. He occupied the Presidency from 1945 to 1959.

25 June 1952

The photographers: Lensmen

Andrew Farren and Pádraig MacBrian were both staff photographers in the Irish Press. Pádraig recalls that his first press photo was of cattle being loaded onto a ship on Dublin's South Wall. At the time, his wages were £1 a week!

In 1952, still only in their twenties, the pair set up Lensmen as a commercial news photographic service, initially in rented offices in Westmoreland Street, Dublin. They covered major news stories for British national newspapers and for the Cork Examiner. In the early 1960s business had expanded substantially, with Lensmen having the agency for all major Irish government departments, as well as working for PR companies and commercial businesses. They bought Nos. 10 and 11 Essex Street, and called it Lensmen House. This developed into a major agency, employing fifteen people, including five photographers. Interestingly, one of their jobs was to take photos of Irish life and events for the Irish editions of British newspapers to replace their 'Page 3 Girl' pictures, which were not considered suitable for Irish readers!

Among the stand-out events they covered were the visits of the Beatles, Princess Grace and President Kennedy. Andy can remember the excitement of being on board one of the US press helicopters going to the Kennedy ancestral home in Dunganstown in 1963.

A key development for the business was the purchase of a wire machine that could transmit photos over the telephone. This was used extensively during the period of Jack Lynch's government, including the fallout from the Northern Troubles.

In the early days they used Linhof cameras with glass plates, both 9x12cm and the US standard 5x4ins. These plates survive in today's Lensmen, run by photographer Susan Kennedy, who bought the business in 1995. The meticulously recorded Lensmen archive includes a record of each day's photographic assignment as well as details of the shoot, making it a valuable visual history resource.

Andrew Farren Padraig MacBrian

This book is dedicated to Andrew Farren and Pádraig MacBrian, photographers and founders of Lensmen, for the excellence and accuracy of their work.

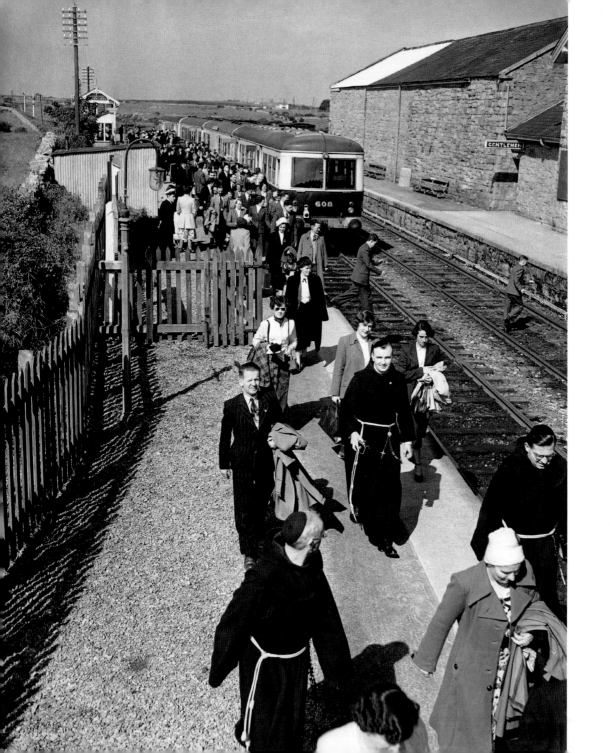

Opposite
Crowds arrive at
Ballyshannon station on
their way to the dedication
of the new Franciscan
Church at Rossnowlagh,
Co Donegal.

29 June 1952

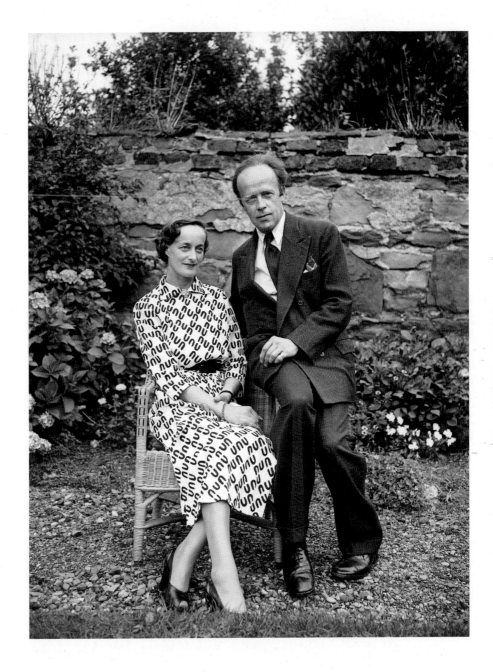

Erskine Childers, Minister
for Posts & Telegraphs,
pictured with his fiancée,
Miss Rita Dudley. Childers
became the fourth President
of Ireland in 1973.

22 August 1952

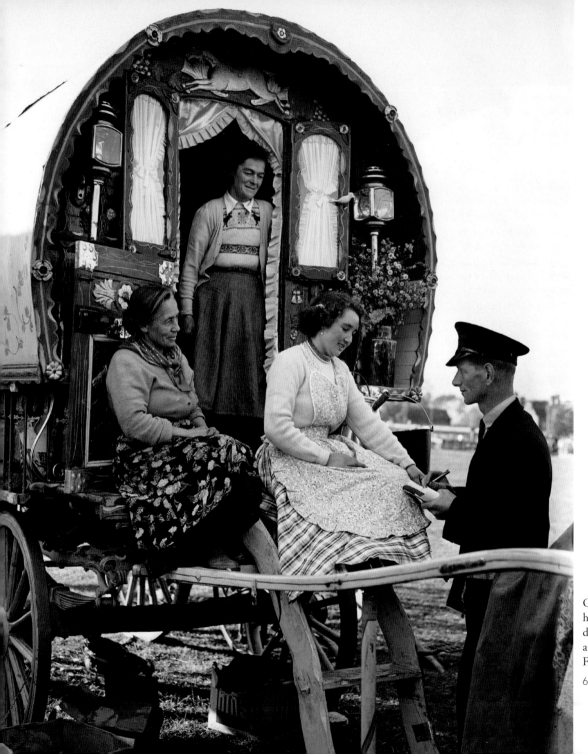

Gypsies in a traditional horse-drawn, highly decorated wagon arrive at Ballinasloe Horse Fair.

6 October 1952

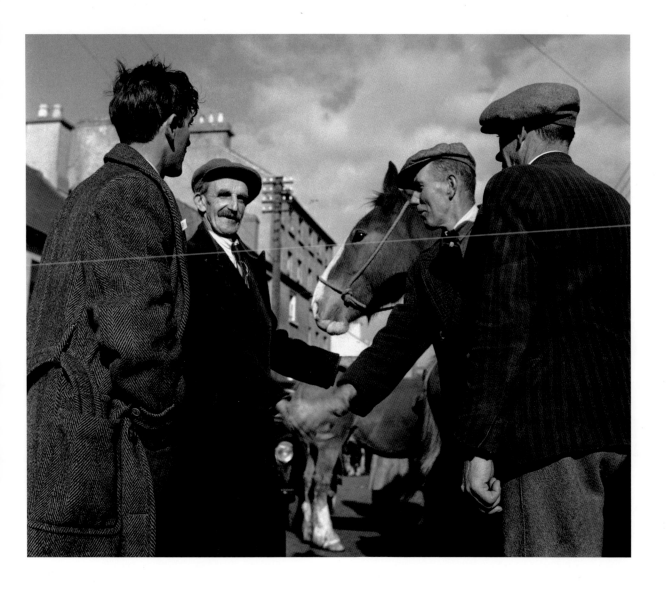

A handshake seals the deal. Horse trading at the
Ballinasloe Fair.

7 October 1952

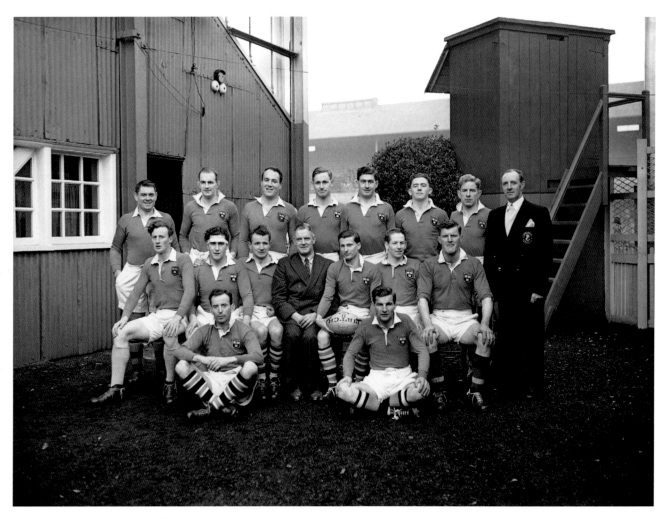

The Munster rugby team line up before a match at
Lansdowne Road.

20 November 1952

Popular singer, actress and all-round entertainer Gracie Fields at Jameson Jewellers,
O'Connell Street. In her heyday she was one of Britain's highest paid performers.
The song with which she is most associated was 'Sally ... Sally, pride of our alley ...'

11 December 1952

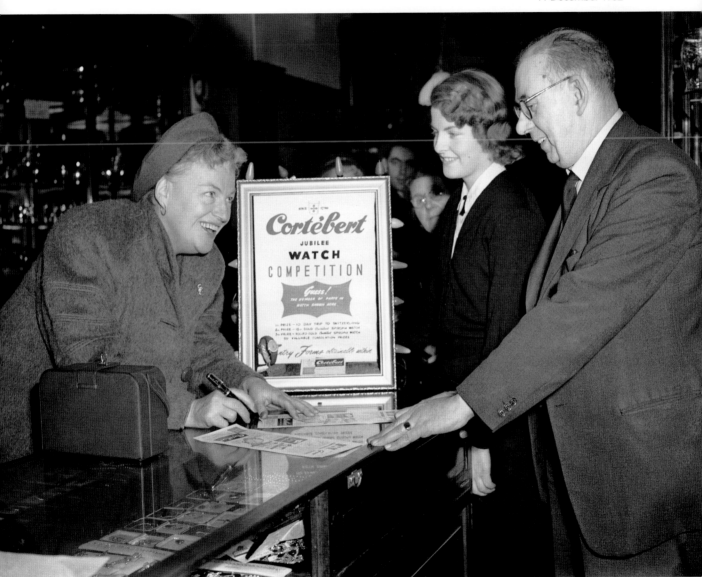

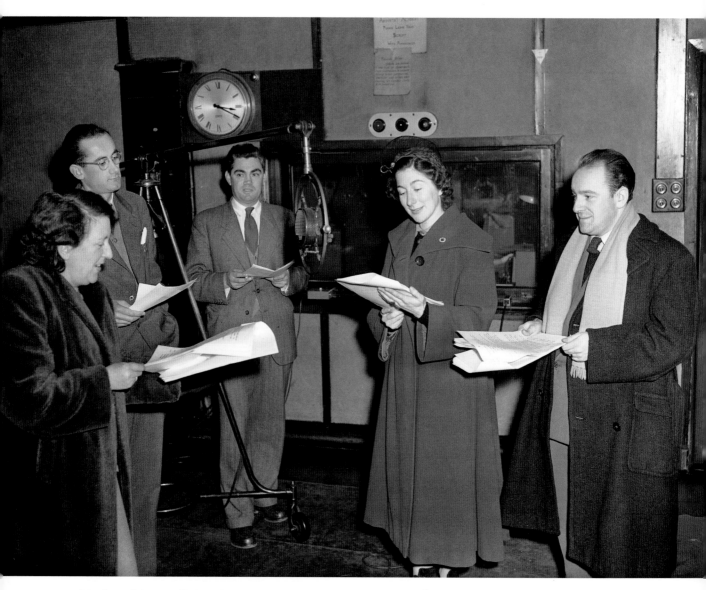

Members of the cast of 'The Foley Family', a light comedy series from Radio Éireann.
Written by David Hayes, the show starred George Green as Tom Foley, Peg Monahan as
Alice, and included Leo Leydon and Florence Lynch.

11 December 1952

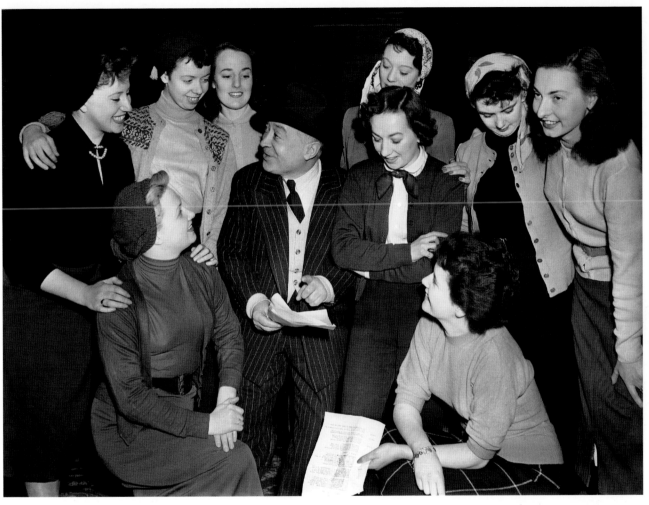

Jimmy O'Dea with Maureen Potter, to the right, and showgirls from 'Still At It,' the Christmas show at the Gaiety. As well as a successful career in theatre and pantomime, O'Dea appeared in films such as *Darby O'Gill and the Little People*.

17 December 1952

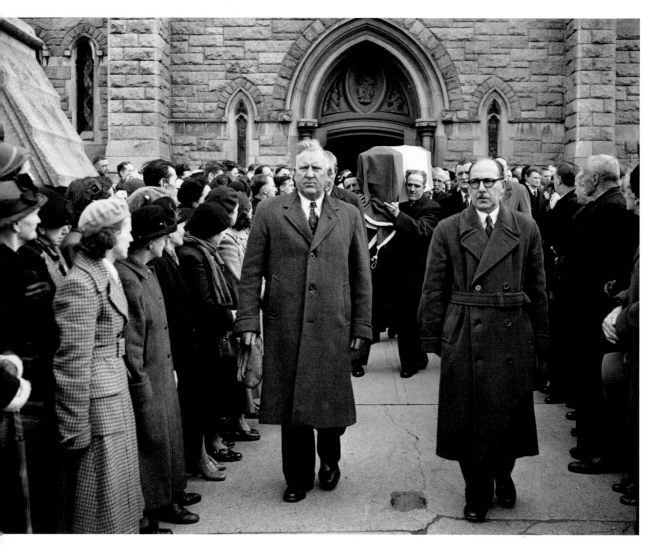

The remains of Maud Gonne MacBride leave the Church of the Sacred Heart, Donnybrook. A revolutionary and nationalist, in 1900, she founded Inghinidhe na hÉireann (Daughters of Ireland), a women's republican movement. Having turned down offers of marriage from WB Yeats, she married Major John MacBride, who was executed in 1916 for his part in the Rising.

29 April 1953

Edgar Bergen, the American actor and ventriloquist, with his famous dummy partner, Charlie McCarthy, in a new suit from Premier Tailors.

12 May 1953

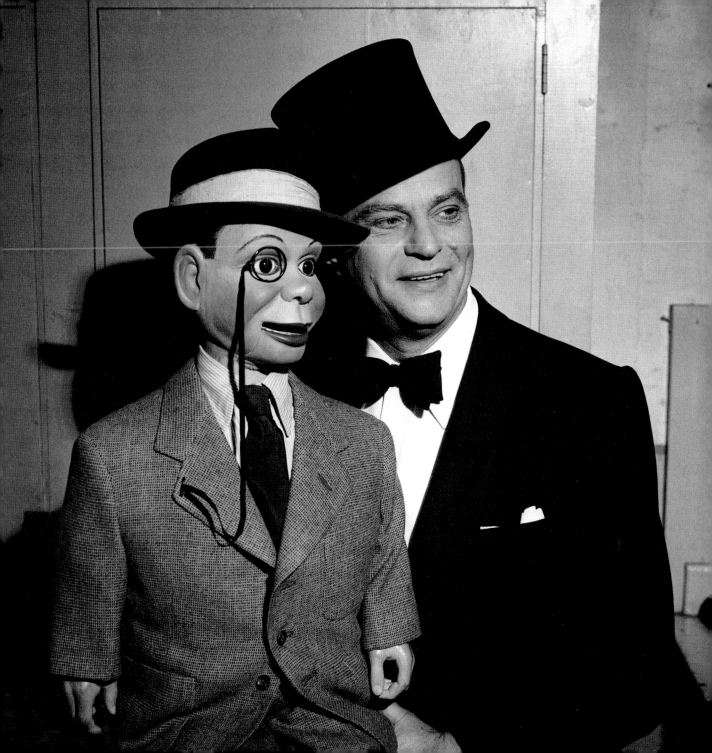

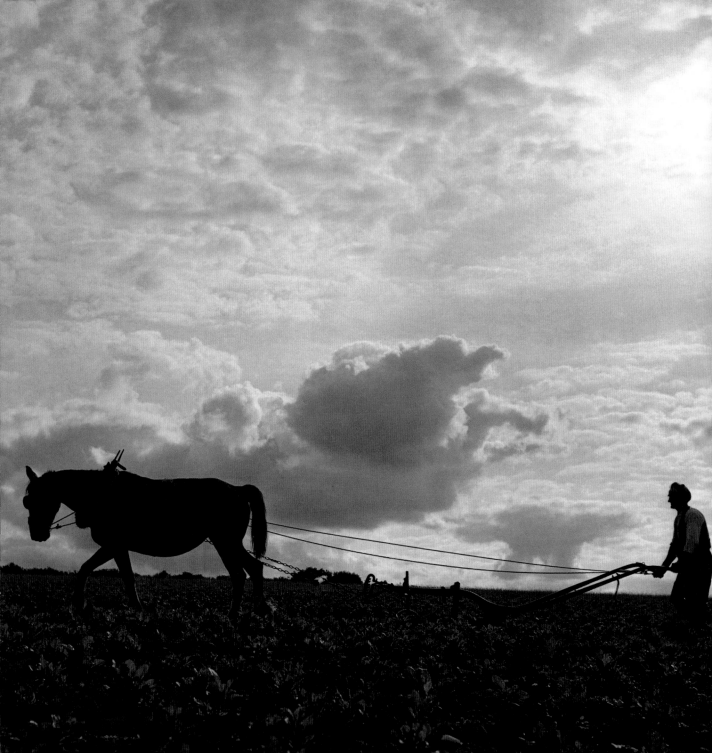

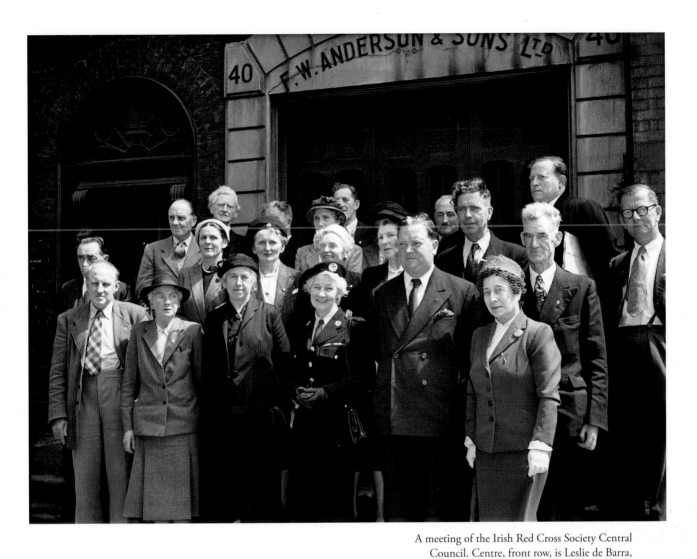

A meeting of the Irish Red Cross Society Central Council. Centre, front row, is Leslie de Barra, a former director of organisation for Cumann na mBan and then President of the Irish Red Cross. On her left is Lord Killanin. Her husband, General Tom Barry, a prominent guerilla leader in the IRA during the War of Independence, is on the right, behind the lady in the veiled hat.

14 July 1953

Farming at Stoneyford, Kilkenny.

5 July 1953

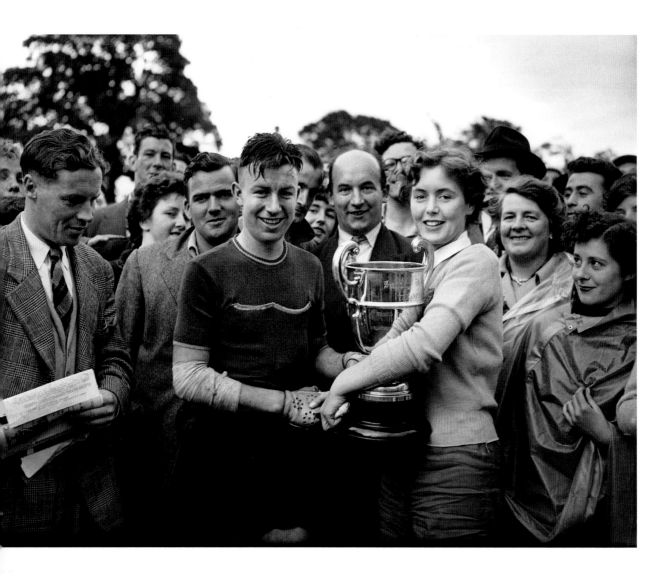

Shay Elliott is presented with the cup on winning the
126-mile championship of Ireland race at Dundalk, Elliott
was the first Irish cyclist to make a mark as a professional
rider in Europe and was also the first Irish rider to wear the
yellow jersey in the Tour de France (1963).

26 July 1953

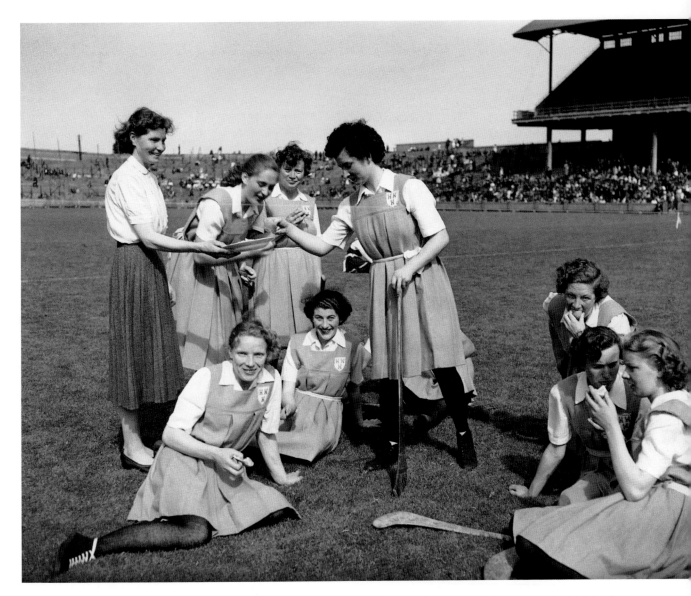

The Dublin team eat their oranges at the All Ireland
Senior Camogie Final at Croke Park. Dublin beat
Tipperary 8-4 to 1-3.

2 August 1953

Fashion designer Neillí Mulcahy (left) heads off on her travels. Trained in Paris, Mulcahy was noted for her innovative use of Irish fabric, including tweed. She was one of the founders of the Irish Haute Couture Group which aimed to promote Irish fashion abroad.

4 August 1953

Robert Taylor (front) and Stanley Baker take a break during filming of *The Knights of the Round Table* at Luttrellstown Castle.

25 August 1953

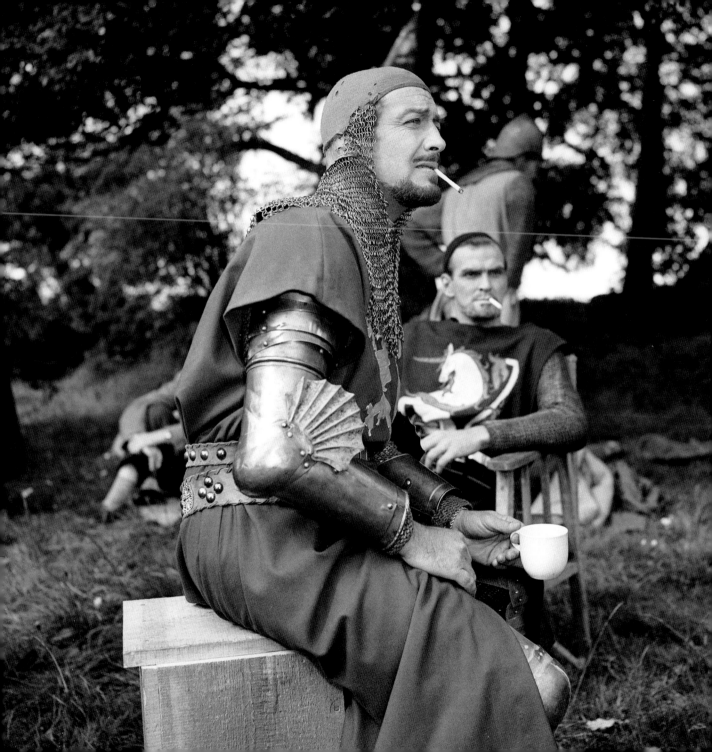

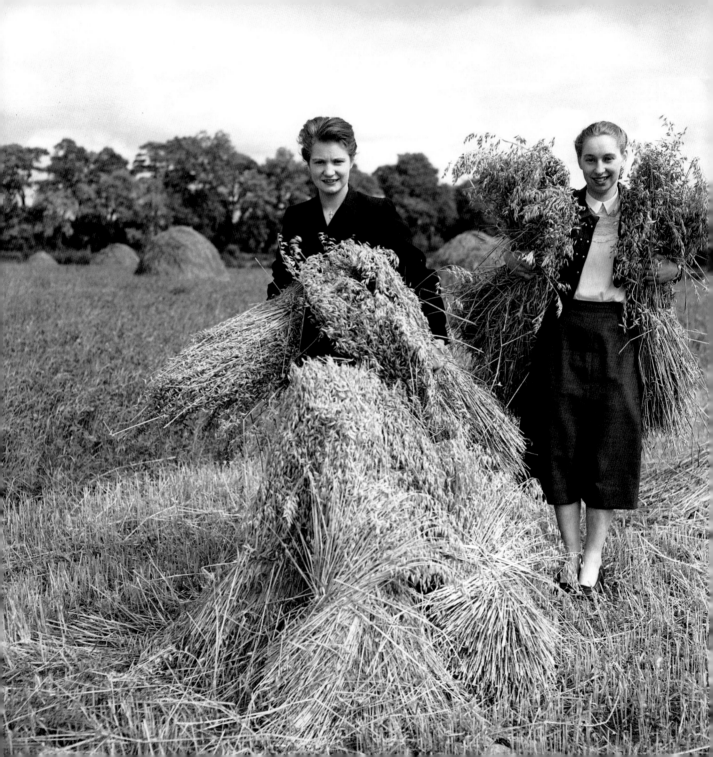

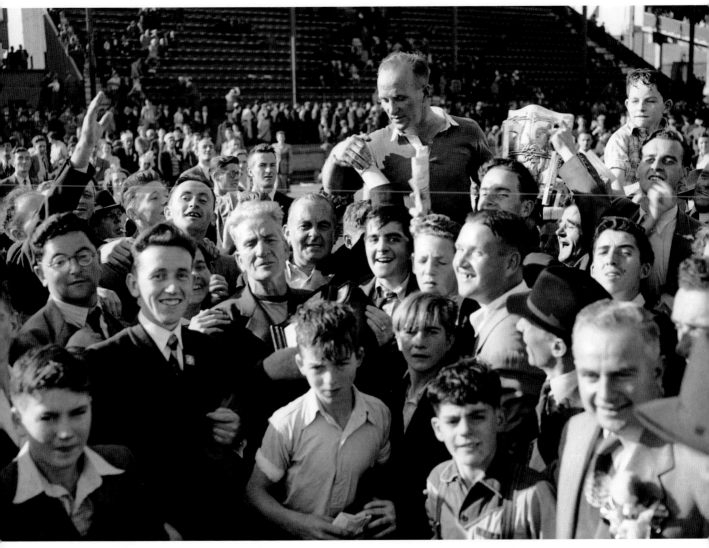

The Misses Ryan help out with the harvesting
at Thurles, Co Tipperary.

2 September 1953

Cork captain Christy Ring is shouldered off the pitch by enthusiastic
supporters after the All Ireland Senior Hurling Final at Croke Park.
Cork beat Galway 3-3 to 0-8, of which Ring scored 1-1. The match
attendance was 71,195.

7 September 1953

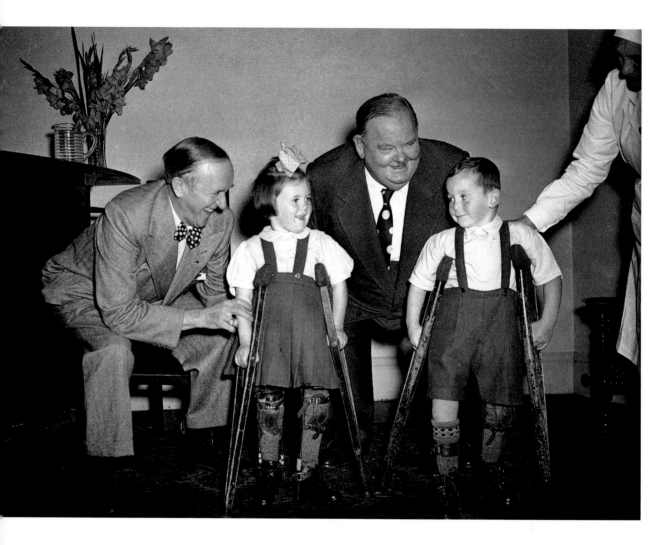

The world-famous comedy duo Stan Laurel (left) and Oliver Hardy with two young polio patients after presenting a cheque in aid of the Little Willie Fund. The boy is Willie O'Reilly who became the mascot of the 'Little Willie' campaign to raise funds for a new hospital following a polio epidemic in Ireland in the 1940s and 1950s.

22 September 1953

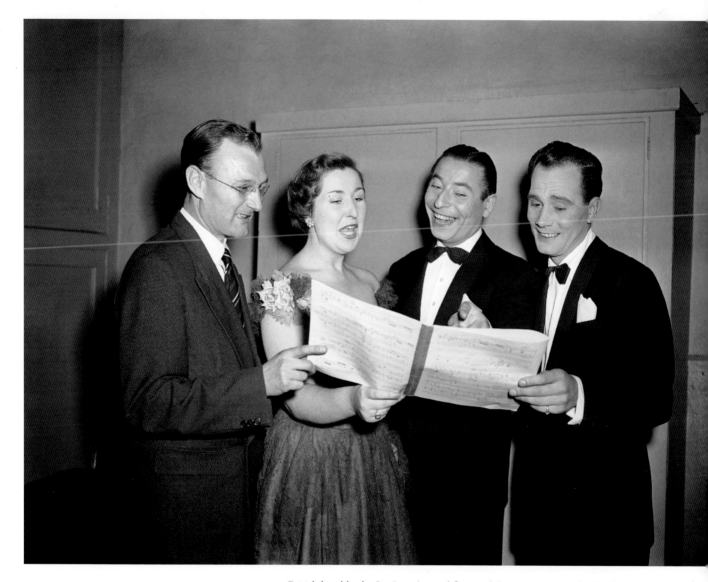

British band leader Joe Loss (second from right), Rose Brennan, the Dublin-born singer with the Joe Loss Orchestra for 15 years, and Norman Metcalfe (far left), resident organist at the Theatre Royal, who also played the musical clues on the TV series 'Quicksilver', rehearse at the theatre.

23 October 1953

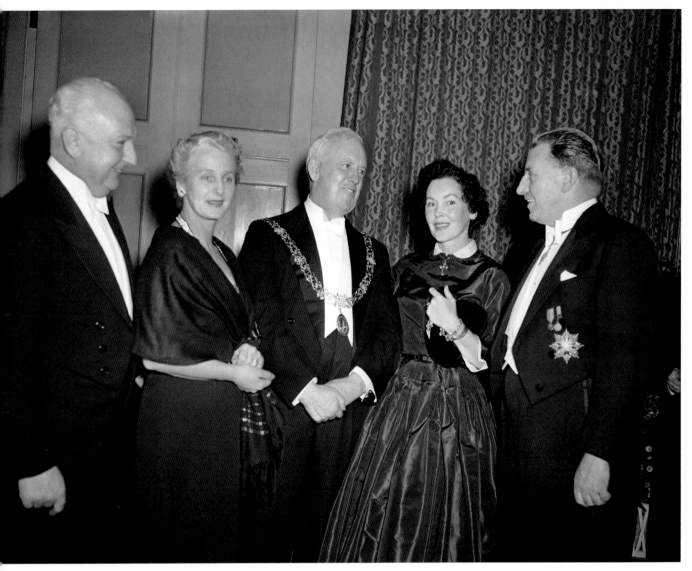

Among those present when American Cardinal Spellman received an honorary degree from the NUI were Sean Lemass (right) and Irish-born film star Maureen O'Sullivan (second right) noted for her role as Jane in the *Tarzan* movies. She was also the mother of actress Mia Farrow.

28 October 1953

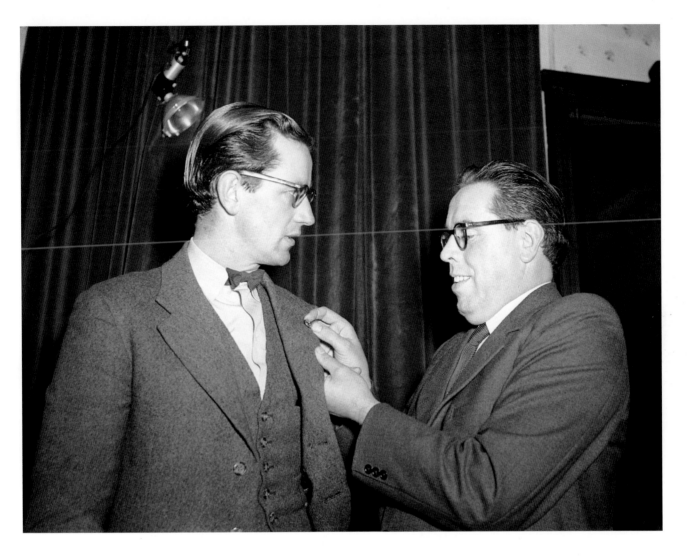

Dr Noel Browne, TD, receives a fáinne, to signify
his ability to speak Irish. As Minister for Health he
introduced mass free screening for TB but came into
conflict with the Catholic Church over his 'Mother
and Child Scheme'. During his political career he
was a TD for five different parties.

14 November 1953

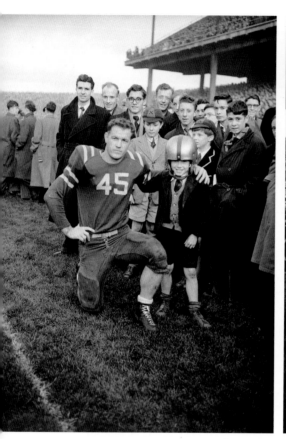

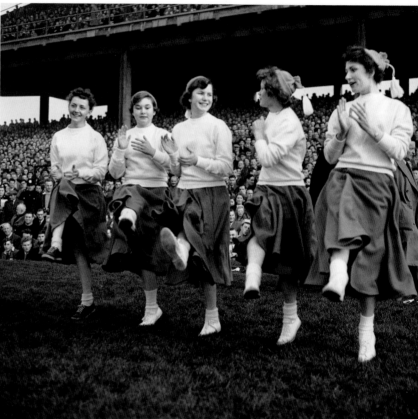

A demonstration of American football at Croke
Park in aid of the Irish Red Cross Society pitted the
Burtonwood Bullets against Wethersfield Raiders.
The cheerleaders proved a big attraction.

21 November 1953

Baby orangutan 'Lily' checks out *Ireland of the
Welcomes* on arrival at Dublin Zoo. Lily was a gift to
the zoo from an Irishman living in Borneo.

7 January 1954

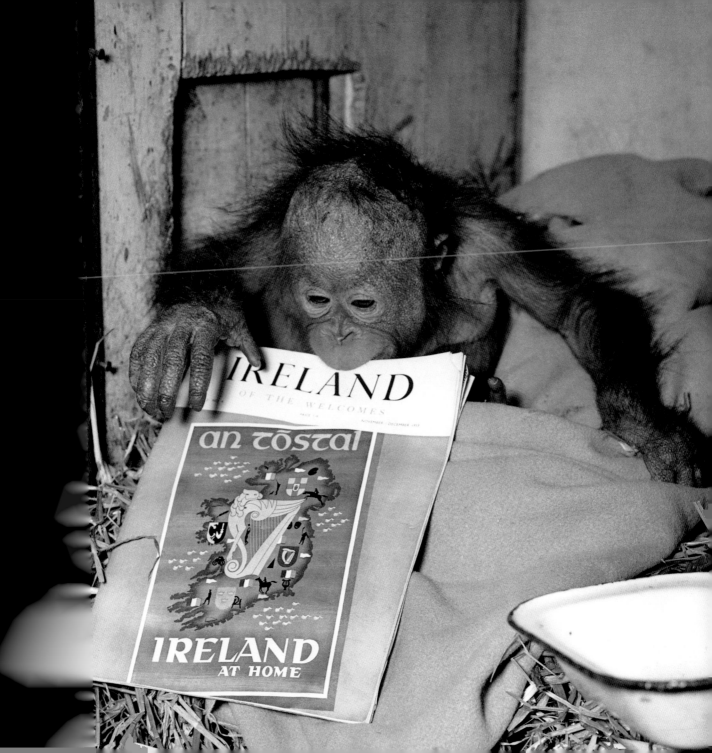

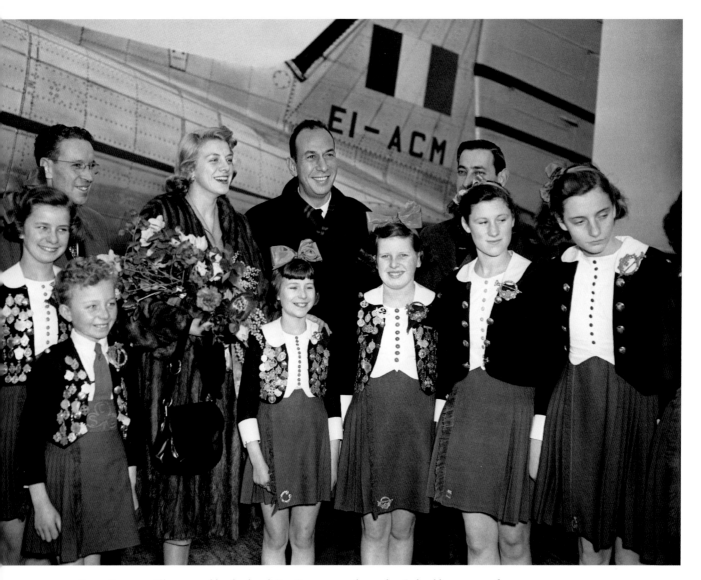

Singer Rosemary Clooney and her husband, Jose Ferrer, are welcomed to Ireland by a group of Irish dancers, proudly displaying their medals. Clooney had a string of hits, including 'Mambo Italiano' and 'This Ole House'. She is the aunt of actor George Clooney. Ferrer was the first Hispanic actor to win an Academy Award.

22 January 1954

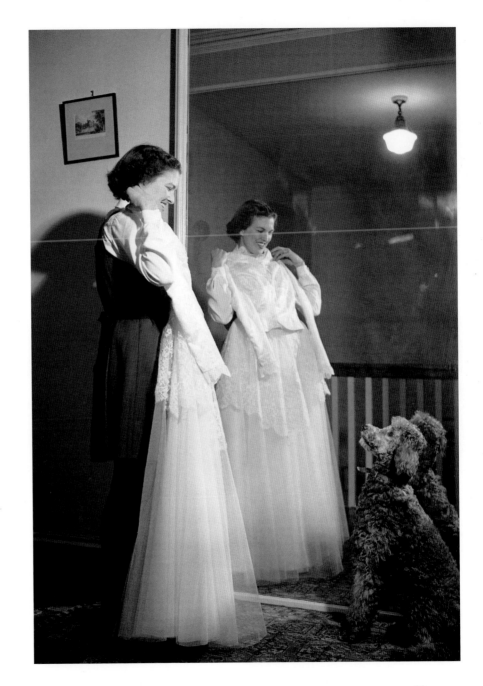

'What do you think?' Maeve Shankey gets doggy approval for her wedding dress just before her marriage to Sean Kyle. An Olympic athlete and hockey player, she was capped 58 times for Ireland and competed in the Melbourne, Rome and Tokyo Games, where she reached the semi-finals of both the 400m and the 800m.

18 February 1954

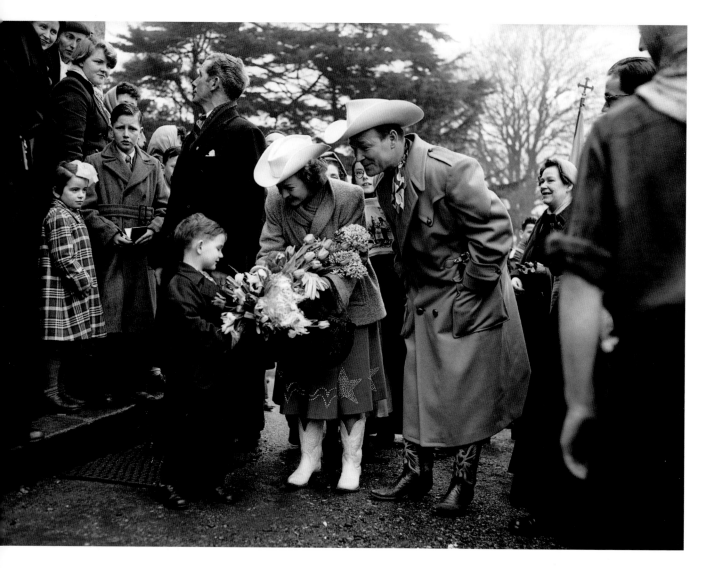

'King of the Cowboys' Roy Rogers and his wife, Dale Evans,
meet boys of St Augustine's School in Blackrock. Rogers and
his horse, Trigger, featured in more than 100 films. As well as
his acting career, Rogers was known as the singing cowboy, and
formed a popular western group, 'Sons of the Pioneers'.

19 March 1954

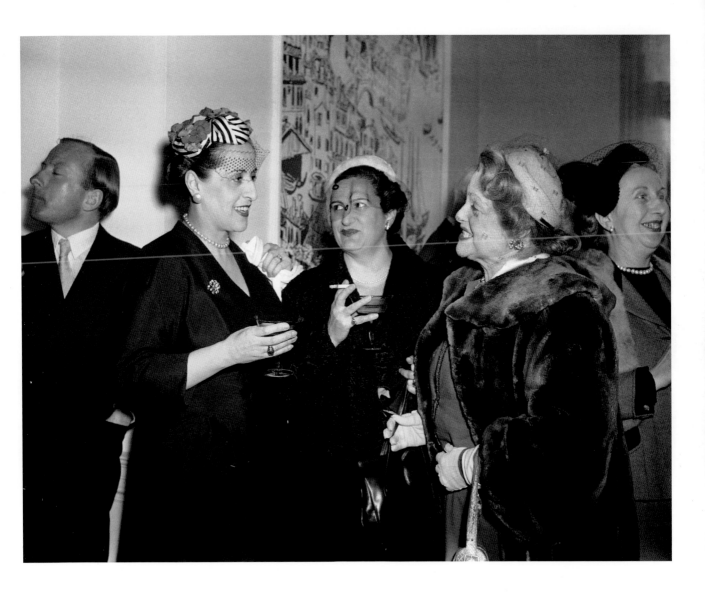

Opera star Margaret Burke Sheridan (second from right, in fur coat) at the inauguration of the Italian Cultural Institute. The Castlebar-born soprano took leading roles in La Scala, Milan and at Covent Garden. Puccini was said to be spellbound by her interpretation of his *Madame Butterfly*.

20 April 1954

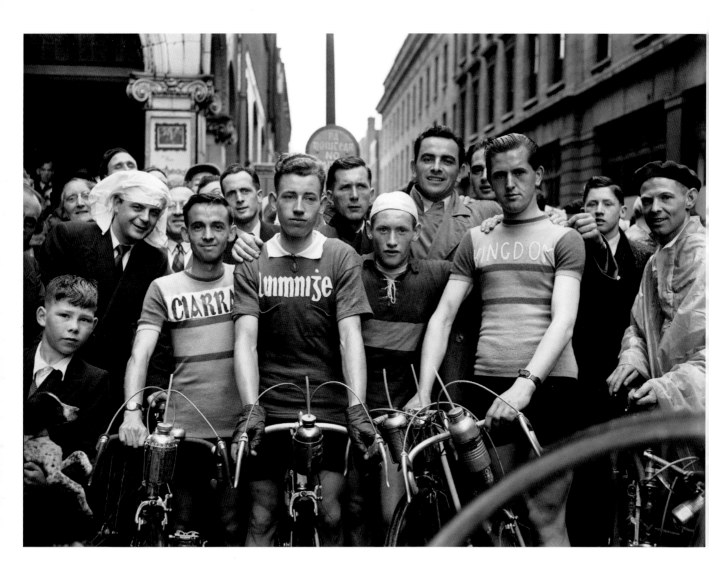

A group of cyclists line up in Prince's Street for the start of
the Rás Tailteann.

23 May 1954

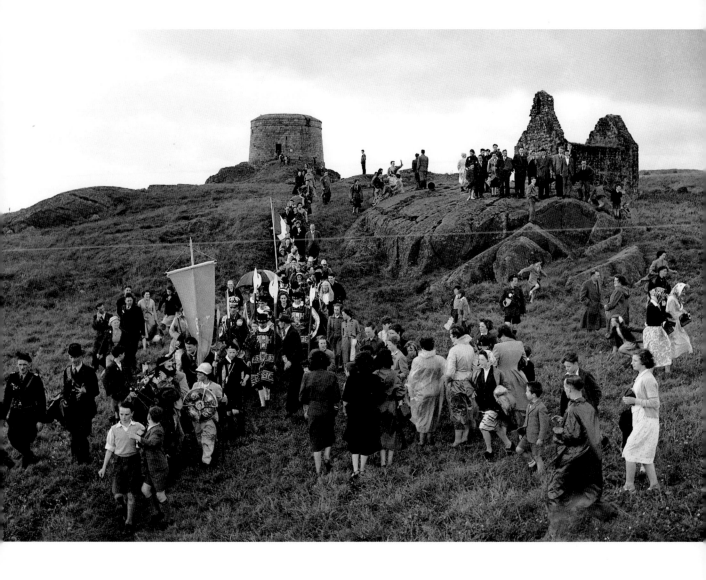

Crowning the King of Dalkey Island. In the late 18th century this mock title was created to make fun of the pomposities of the government. The King was also Baron of Bulloch, Seigneur of Sandycove, Elector of Lambay and Ireland's Eye, and Sovereign of the Most Illustrious Order of the Lobster and Periwinkle!

18 July 1954

43

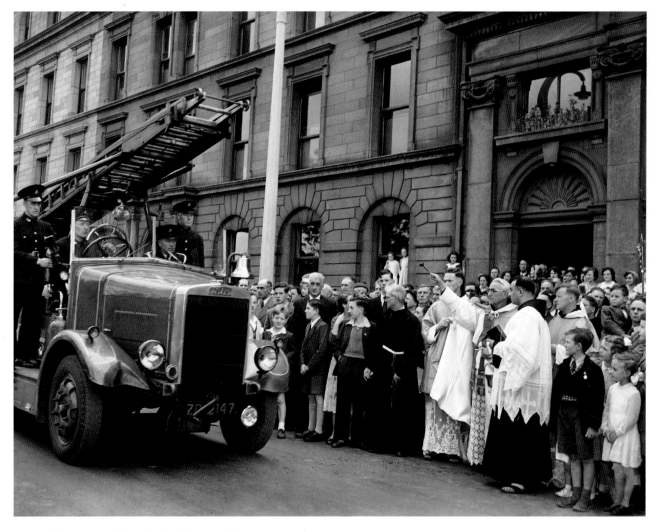

A fire engine is blessed at the Franciscan Friary,
Merchant's Quay, as part of the annual transport
blessing on the feast of St Christopher.

25 July 1954

A 15lb head of cabbage grown by Mr C Kelly
of Drumcondra is proudly displayed
by his son, Tony.

10 August 1954

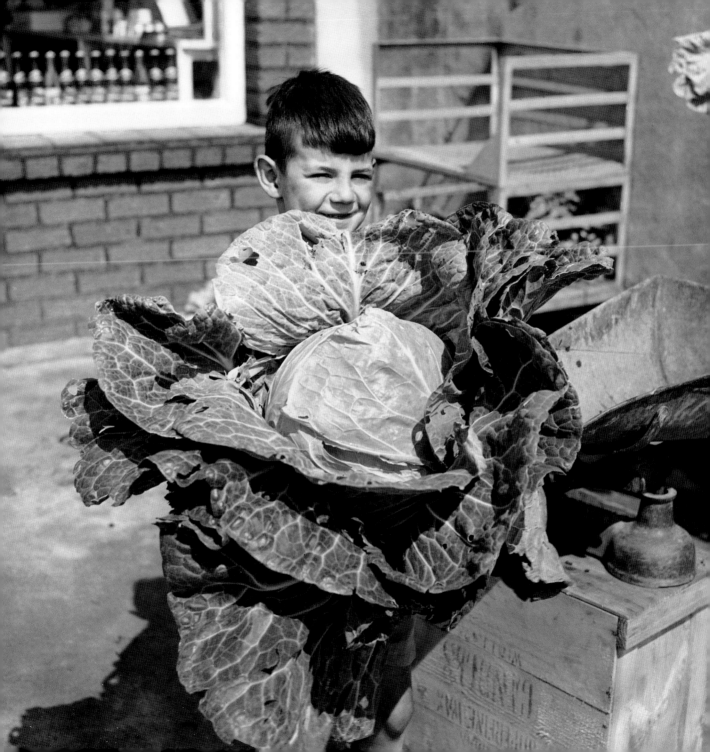

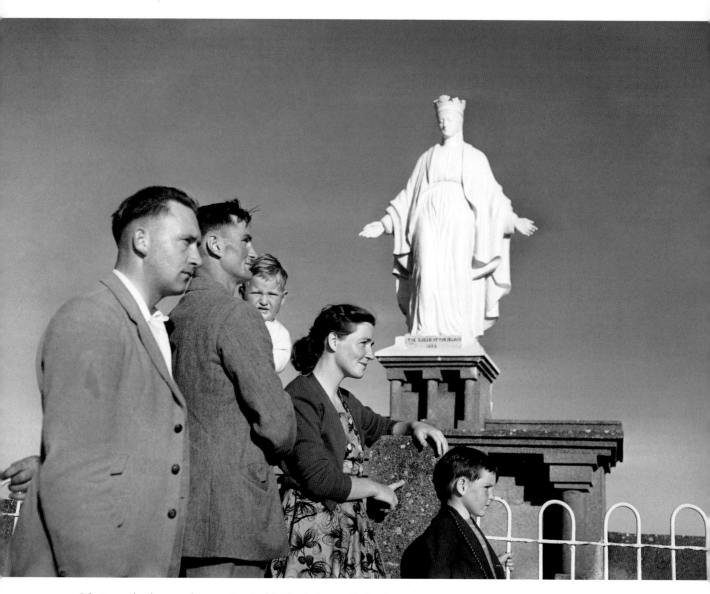

Pilgrims make the annual visit to Our Lady's Island, Co Wexford. Pilgrimages or 'patterns' to religious sites or wells of local saints reputed to have cures for various ailments were commonplace, especially on the feast day of the saint.

13 August 1954

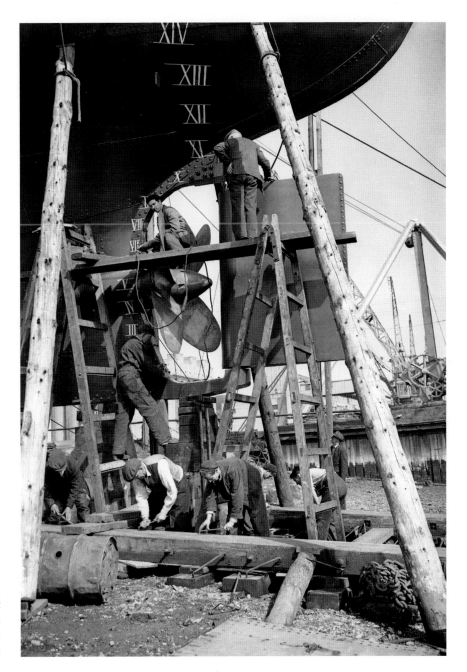

Busy at work on the *Irish Fern*, an Irish Shipping vessel built at the Liffey Dockyards and launched in 1954.

26 August 1954

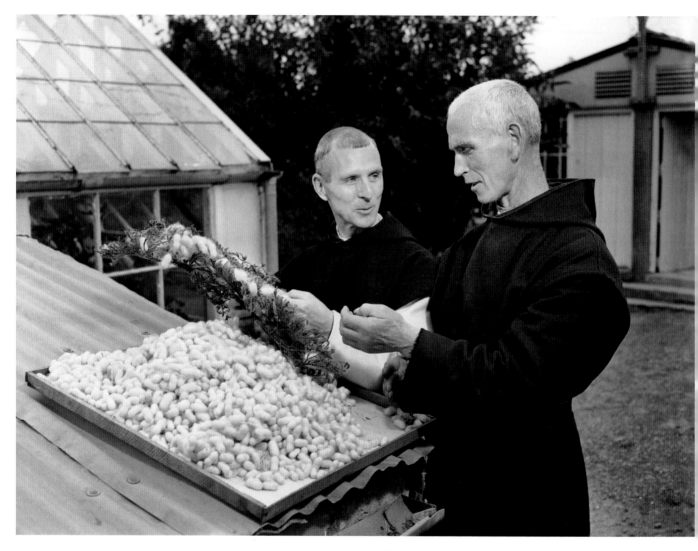

Fr Dermot Coleman (left) examines silkworm larvae at the Cistercian Abbey of Mount St Joseph, Roscrea, Co Tipperary. The monks' main income came from farming, but they were also involved in silk weaving.

2 September 1954

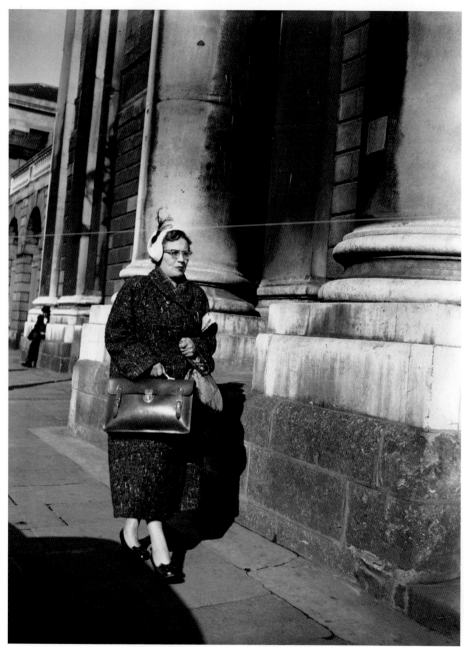

Maureen O'Carroll TD arrives at the High Court for a case involving Batchelors Peas. A founder of the Lower Prices Council, she served as Labour Party TD for Dublin North Central from 1954 to 1957 and was also Labour Chief Whip. She was the mother of BAFTA award-winning comedian Brendan O'Carroll.

29 September 1954

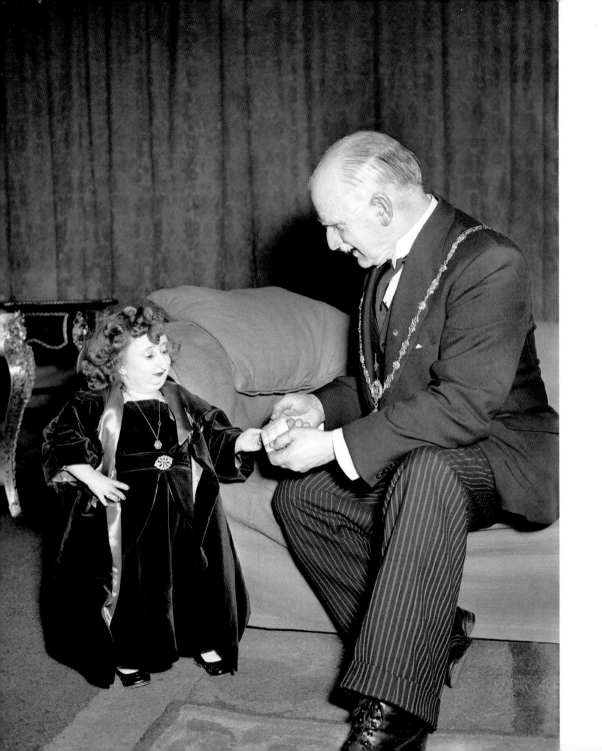

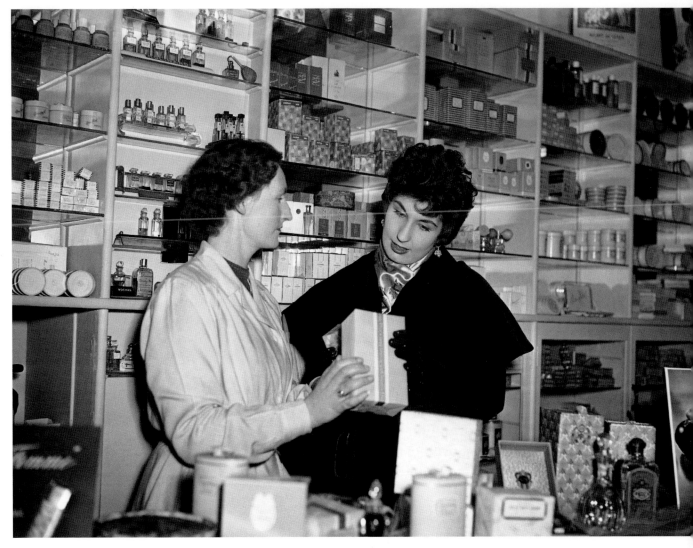

Lord Mayor Alfie Byrne receives a charitable donation from a 22inch performer from the Fun Palace Amusement Centre.

29 November 1954

Alma Cogan at Woulfe's Chemists, Grafton Street. A hugely popular singer in the 1950s, she was the highest paid British entertainer of her era. She had many international hits, including 'Never Do a Tango with an Eskimo'.

7 December 1954

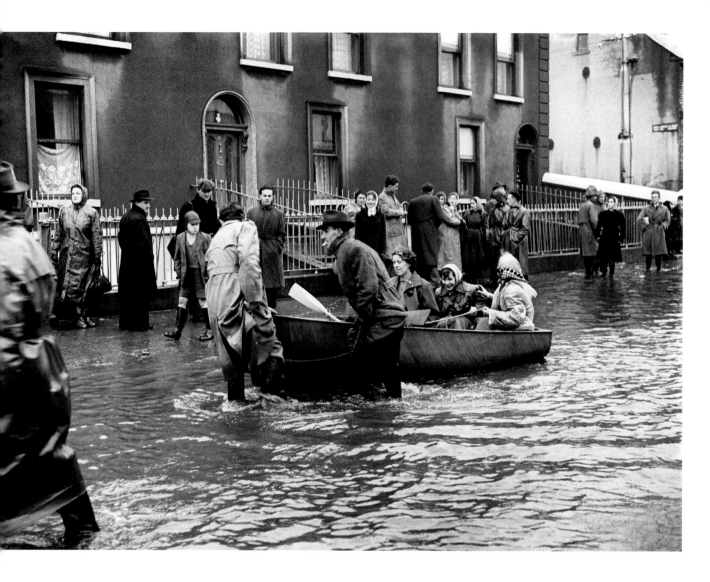

Severe storms during this week in December 1954
brought flooding to many parts, including the North
Strand, seen here, which was described as 'more Venice
than Dublin'.

12 December 1954

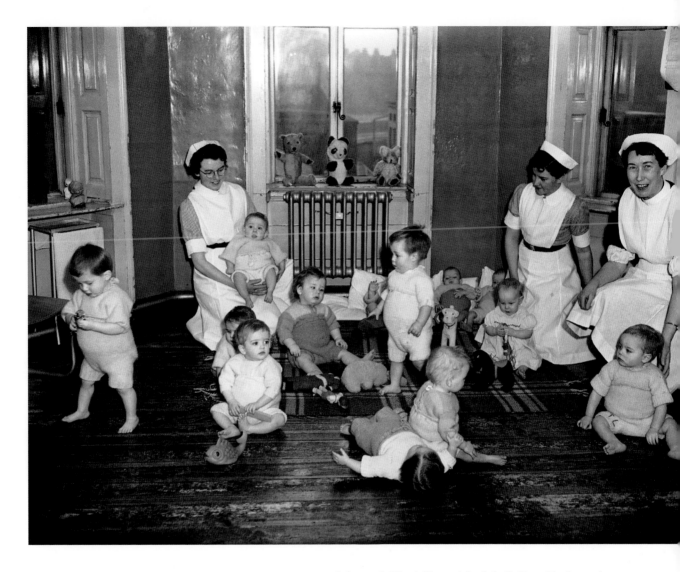

Babies at St Ultan's Hospital for Sick Children. The hospital was established in 1919 by Dr Kathleen Lynn and Madeleine ffrench-Mullen. St Ultan's addressed the very high mortality rate of children living in the tenements and did pioneering work in the treatment of TB.

13 January 1955

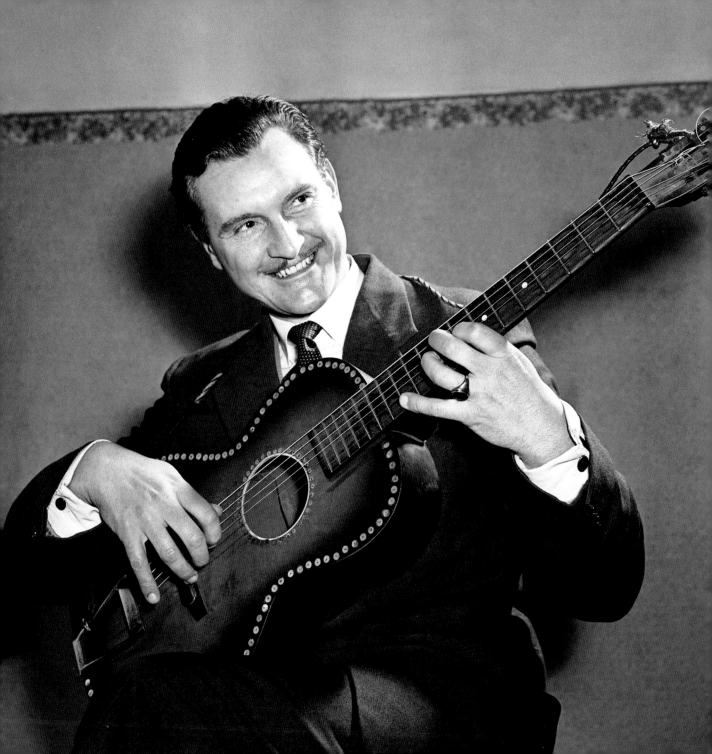

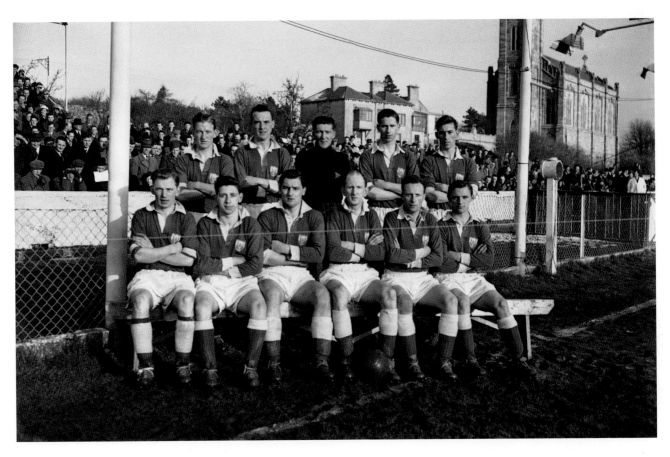

The Cork Athletic team who played
St Patrick's Athletic at Chapelizod.

13 February 1955

Derry-born Charlie McGee was a very popular
balladeer, singing songs such as 'The Homes of
Donegal' to the accompaniment of his guitar. He was
a regular on the Walton's-sponsored radio programme,
where presenter Leo Maguire would invariably
introduce him as 'Charlie McGee and his Gay Guitar'.

12 February 1955

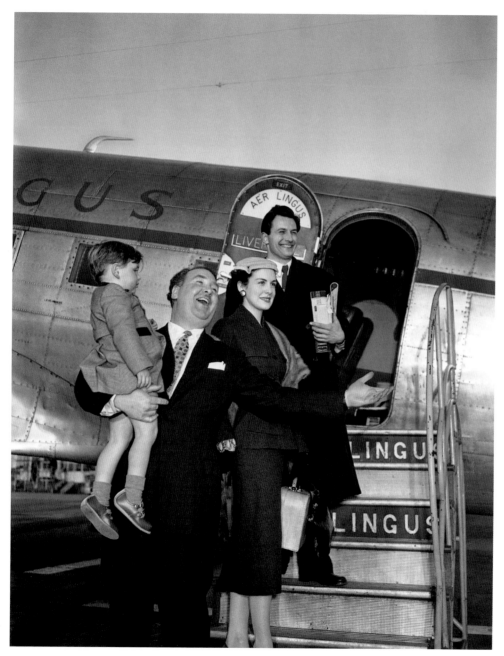

Famous tenor Josef Locke (born Joseph McLaughlin in Derry) strikes a familiar operatic pose on arrival at Dublin airport. Locke specialised in excerpts from operettas, including 'Hear My Song' and perhaps his best known, 'Goodbye', from 'The White Horse Inn', as well as Italian favourites like 'Come Back to Sorrento' and 'Santa Lucia'.

24 March 1955

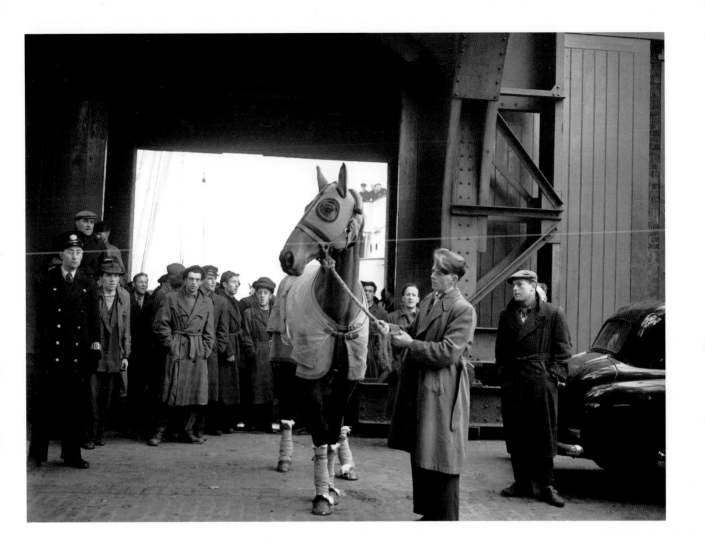

Aintree Grand National winner *Quare
Times* arrives home. It was a third
successive National winner for trainer
Vincent O'Brien. The horse was ridden
by Pat Taaffe.

29 March 1955

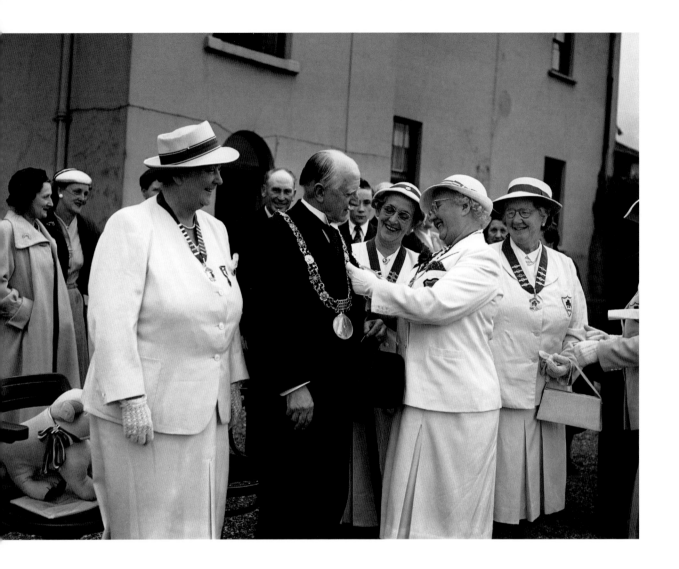

Mayor Alfie Byrne has a new pin added to his chain of office by one of the captains of the women's bowling teams prior to an international series between Ireland, England, Scotland and Wales at Clontarf.

20 June 1955

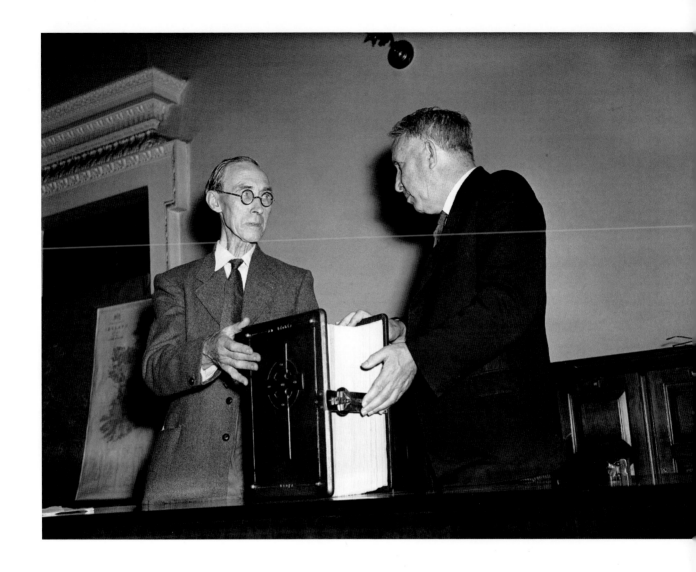

Ceann Comhairle Patrick Hogan (right) is presented with an Irish translation of the Bible by novelist, playwright and teacher Peadar Ó Dubhda, who had spent twelve years translating the Douay Bible.

12 July 1955

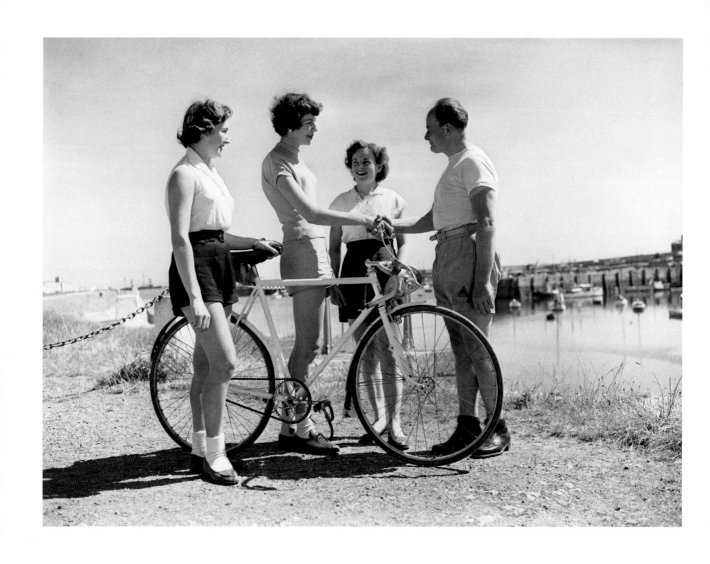

Joy McVeigh, Belfast, is congratulated on becoming 'Miss Cycling'. She was one of the few women cyclists of the era.

13 July 1955

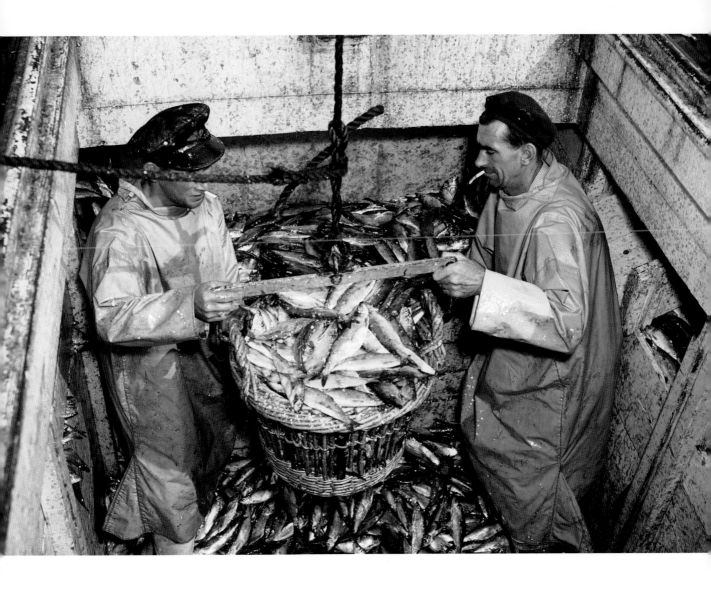

Fishermen unload a catch of herring at Howth.

25 August 1955

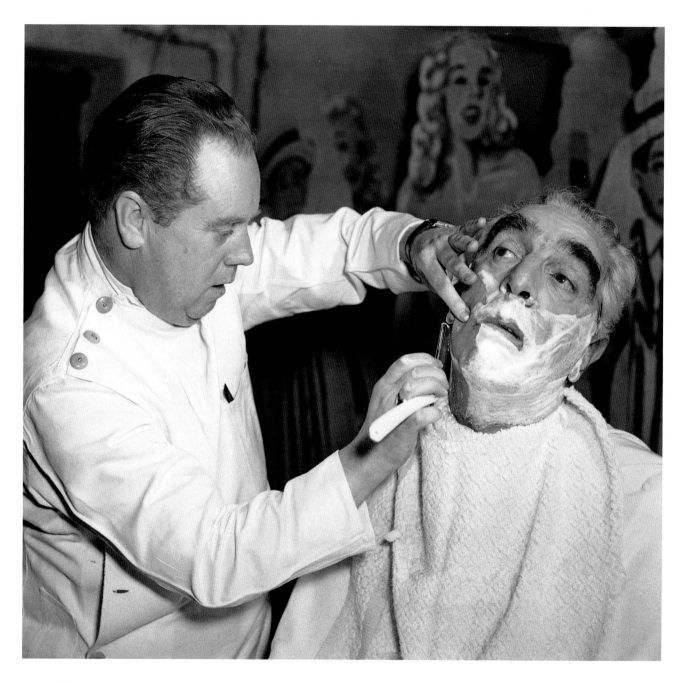

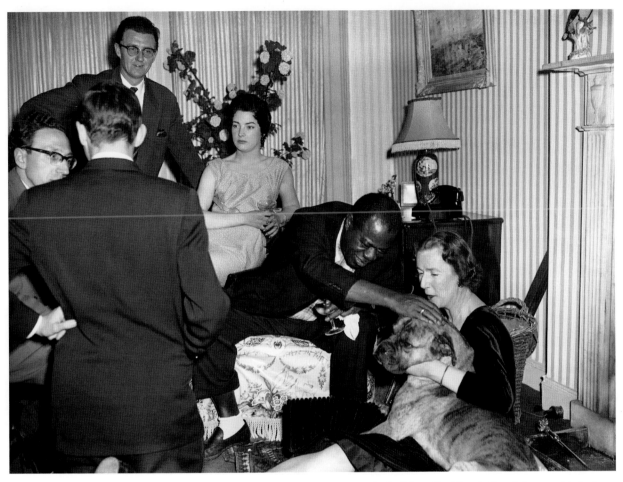

Noel Purcell has his beard removed in preparation for the Christmas pantomime. The Irish stage and television actor had roles in a number of films including *Captain Boycott* (1947) and *Moby Dick* (1956). He is also remembered for singing the Leo Maguire-composed 'The Dublin Saunter'... 'Dublin can be heaven, with coffee at eleven ...'

23 December 1955

Lady Valerie Goulding (right of picture, with dog) hosts a party for Louis Armstrong at Enniskerry. Armstrong, nicknamed 'Satchmo', was a hugely influential jazz trumpeter and singer. His unique voice made hits of songs such as 'What a Wonderful World', 'Hello Dolly', and 'We Have All the Time in the World'..

9 May 1956

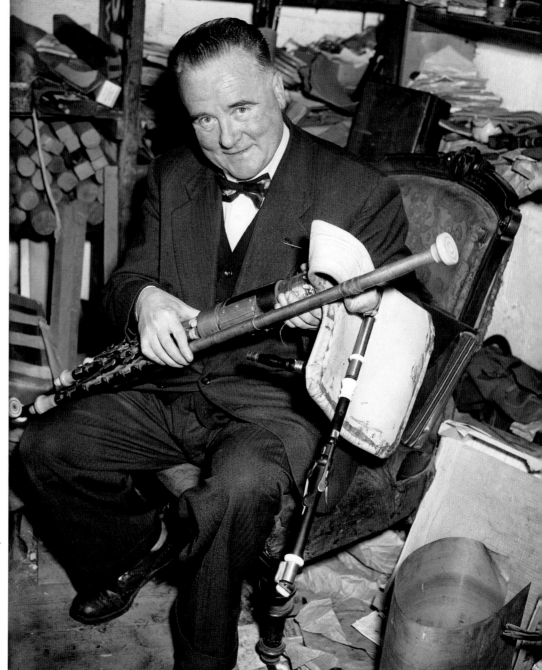

Leo Rowsome in his workshop. Rowsome was the third generation of an unbroken line of uilleann pipers. He was a performer, manufacturer and teacher of the uilleann pipes – the complete master of his instrument.

16 June 1956

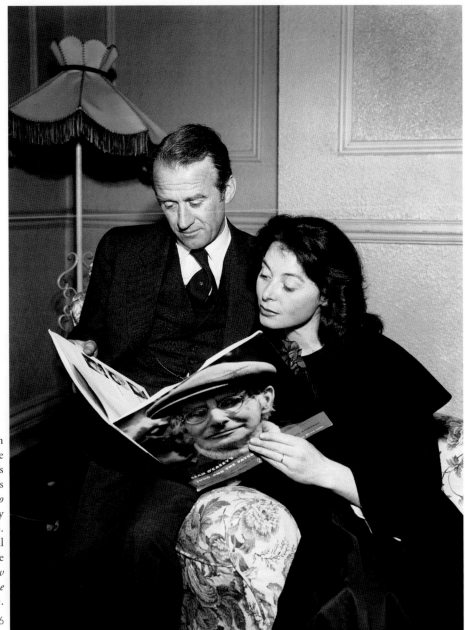

Cyril Cusack and Siobhan McKenna reading the programme for Cusack's production of Sean O'Casey's *Juno and the Paycock*. *Juno* was first staged at the Abbey Theatre in Dublin in 1924. It is the second of his well known 'Dublin Trilogy', the other two being *The Shadow of a Gunman* (1923) and *The Plough and the Stars* (1926).

17 June 1956

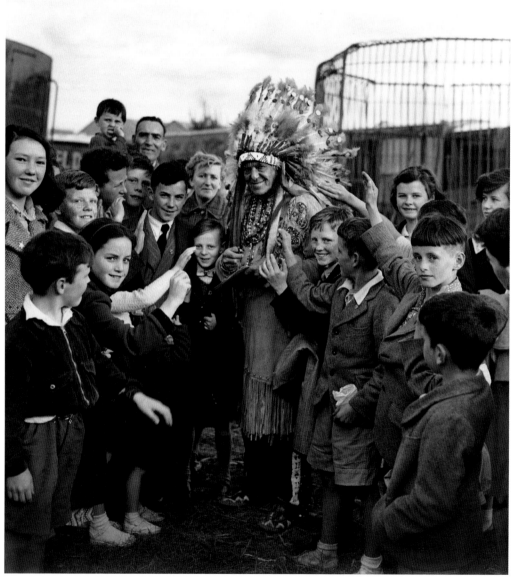

A feathered 'Red Indian Chief' from Chipperfields' Circus with young admirers. Travelling circuses were regular visitors to Ireland, and we also had the Irish-based Duffys and Fossetts Circuses.

3 August 1956

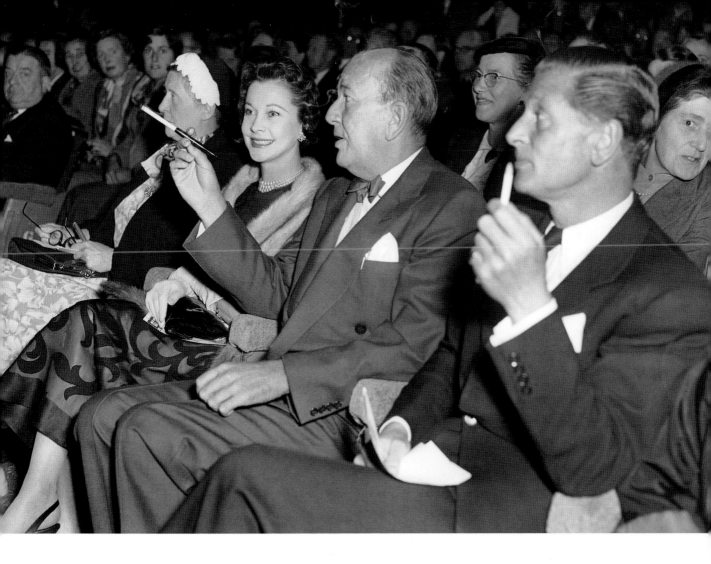

Vivian Leigh with Noël Coward at the Olympia Theatre. Leigh won an
Academy Award as Blanche DuBois in *A Streetcar Named Desire* (1951),
as well as for her portrayal of Scarlett O'Hara in *Gone with the Wind*. Noël
Coward achieved enduring success as a playwright and songwriter and was
famed for his wit and flamboyance. Many of his works, including
Blithe Spirit are still preformed regularly.

4 October 1956

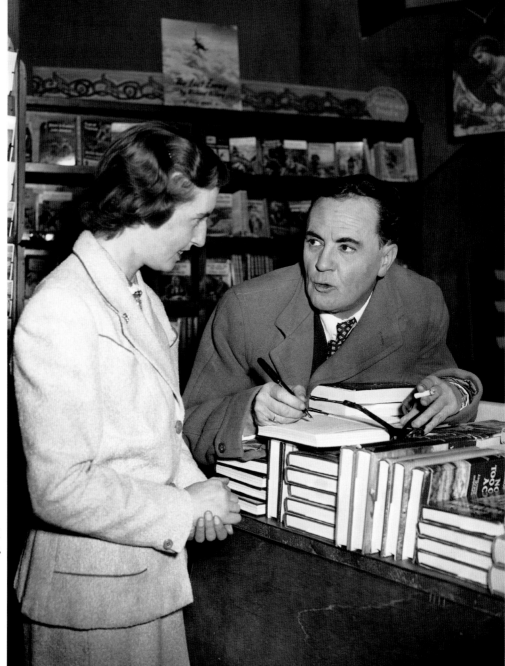

Micheál Mac
Liammóir signs a
copy of his book,
*Aisteoiri faoi Dhá
Sholas* for Iris Kellett.
The English-born
Irish actor, dramatist,
impresario, writer and
poet was a co-founder,
with Hilton Edwards,
of the Gate theatre.
Noted horsewoman
Kellett excelled as a
competitor, trainer,
breeder and horse
producer.

5 October 1956

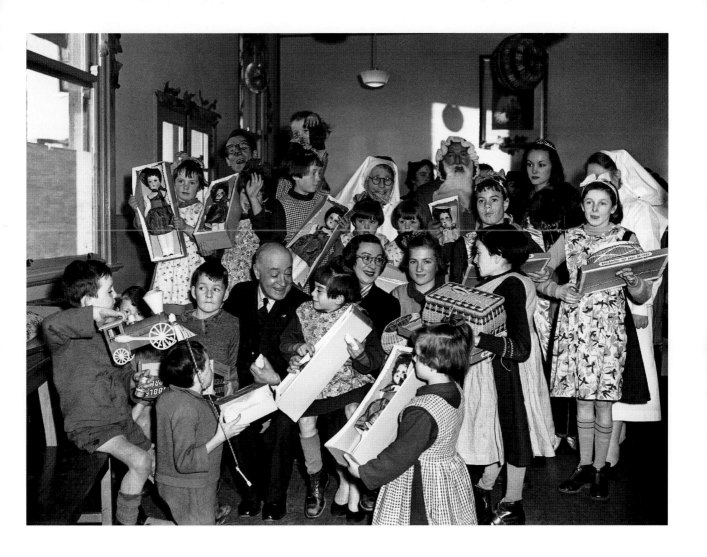

Children receiving their Christmas presents
at Baldoyle hospital from Santa, helped out
by Jimmy O'Dea and Maureen Potter.

18 December 1956

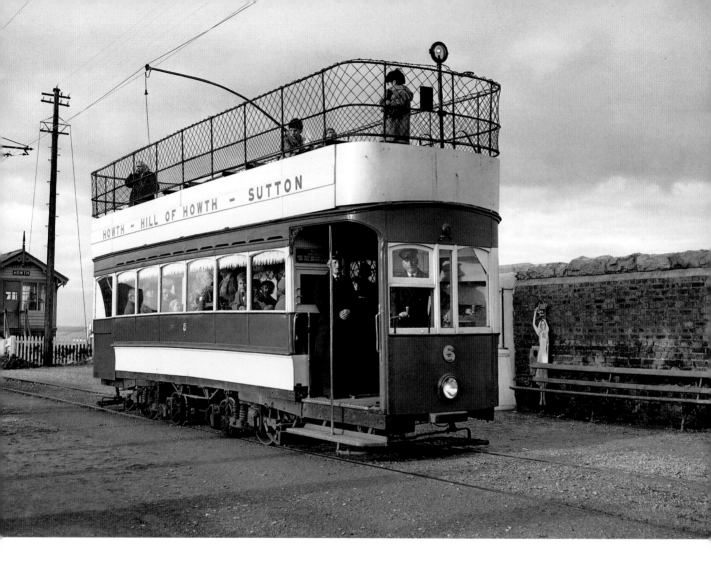

The Howth tram operated from June 1901 to 31 May 1959 and served Howth Head. The service was run by the Great Northern Railway (Ireland) (GNR(I)), which viewed it as a way to bring more customers to its railway stations at Sutton and Howth.

20 December 1956

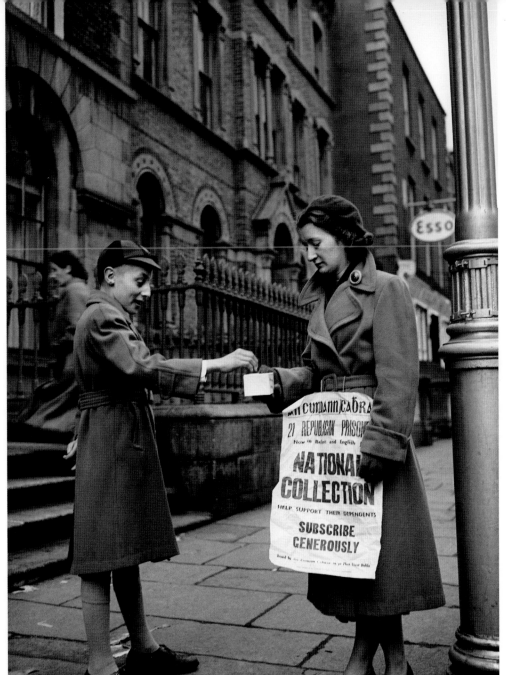

A schoolboy contributes to the national collection of *An Cumann Cabhrach*, the aid committee for the relief of republican prisoners and their families.

23 December 1956

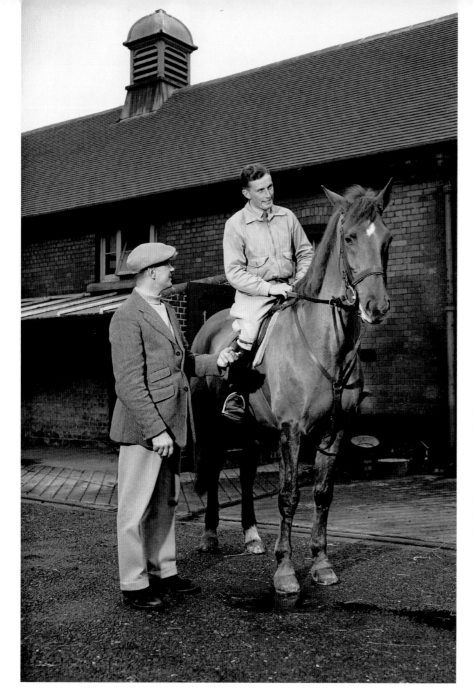

Noted showjumper Seamus Hayes, (left), appointed civilian trainer to the Irish Army Equitation School, with Lieut Billy Ringrose (on horse). Capt Ringrose was a member of the Aga Khan winning team in 1963. Later, as Colonel, he was Chef d'Equipe to the Irish team and main Arena Director for the Dublin Horse Show and is a retired RDS President.

3 January 1957

Not just a toy, the abacus with its brightly coloured wooden beads was used to teach children how to count.

4 January 1957

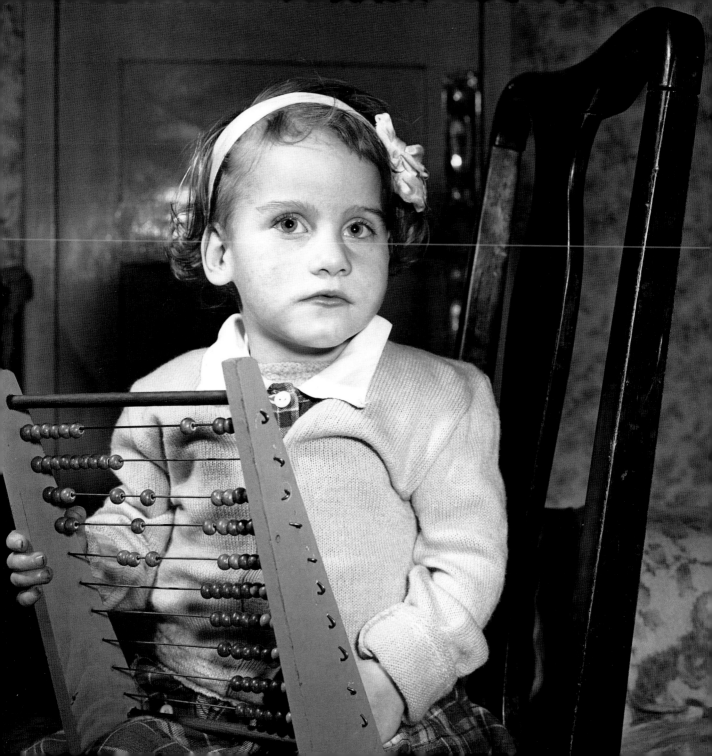

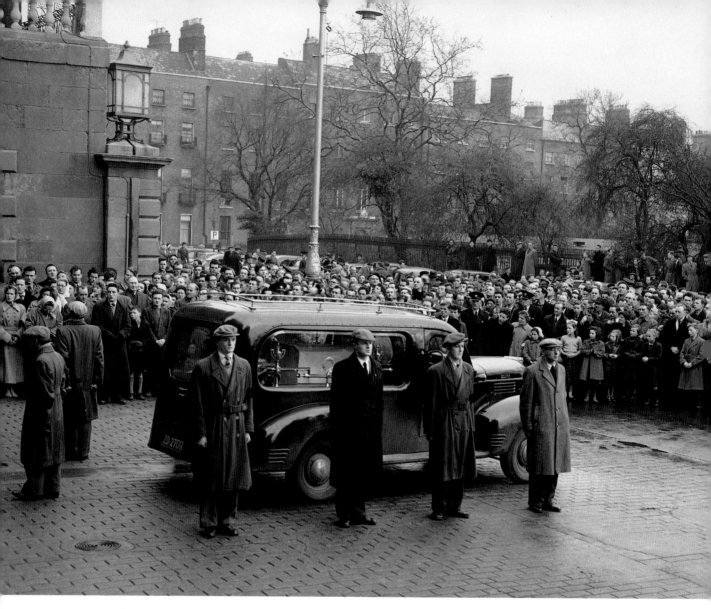

Funeral of Seán South. South was a member of an IRA military column led by Sean Garland on a raid against a Royal Ulster Constabulary barracks in Brookeborough, County Fermanagh, on New Year's Day, 1957. South, along with Fergal O'Hanlon, died of wounds sustained during the raid. The attack on the barracks inspired a popular rebel song: 'Seán South of Garryowen'.

4 January 1957

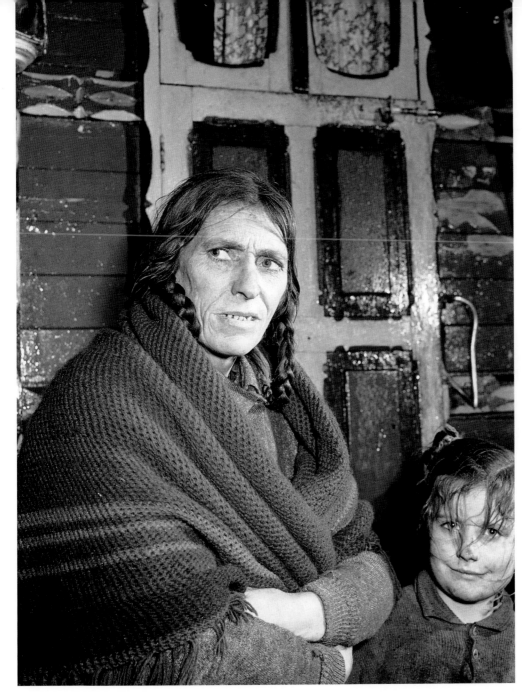

Mrs Bridget Stokes on the bog road, Ballinasloe. A Traveller, or 'tinker' as was generally used in those days, the photograph accompanied a story about housing conditions for travelling people.

28 January 1957

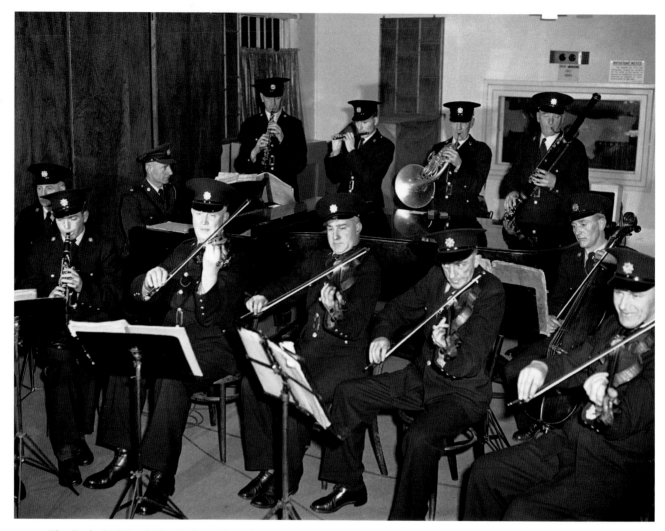

The Garda Céilí Band. The Garda Band was formed shortly after the foundation of the force. It gave its first public performance on Easter Monday, 1923. The first Bandmaster was Superintendent DJ Delaney who formed a céilí and pipe band within the Garda Band. Having been disbanded in 1965, the Garda Band was reformed in 1972 to celebrate the 50th anniversary of the foundation of the Garda Síochána.

31 January 1957

Michael Hughes pictured with the gold he found in Co Monaghan. Significant finds of the precious metal have been made in the county over the years.

1 February 1957

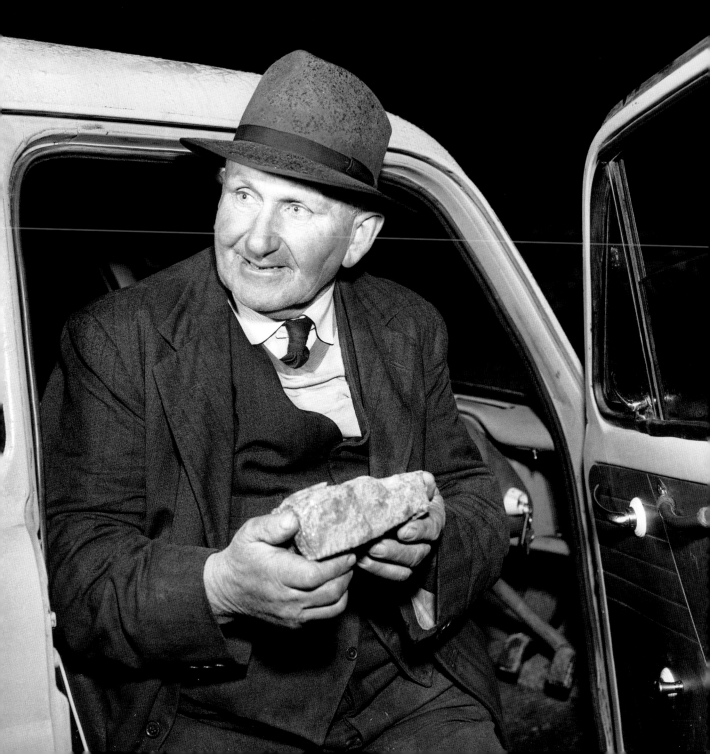

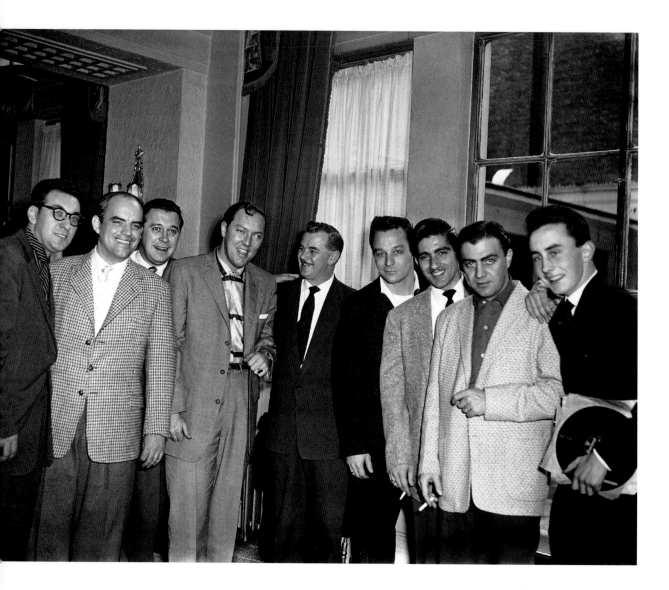

Bill Haley (fourth from left, with his famous 'spit curl') and the Comets, on a visit to
Ireland. The American rock and roll band began in 1952. During late 1954-late 1956, the
group had nine singles in the Top 20. Their most famous and enduring No 1 hit was 'Rock
Around The Clock', recorded in 1954.

27 February 1957

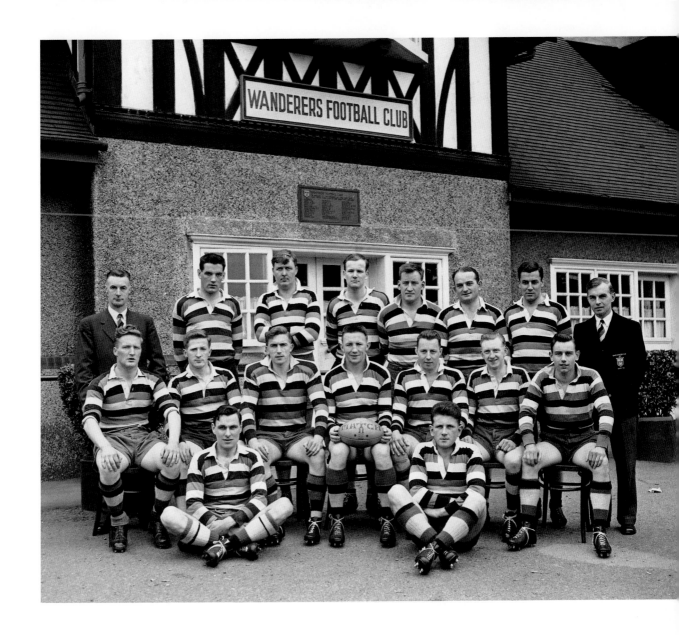

Wanderers Rugby Football Team.

18 March 1957

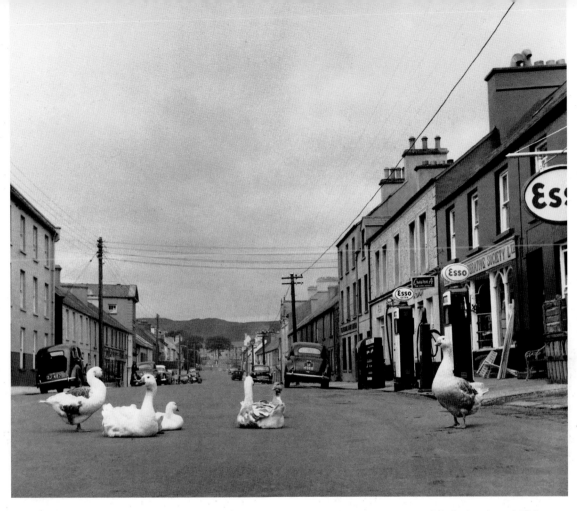

TD Jack Lynch arrives for the reopening of the 16th
Dáil. Elected for Cork in 1948, he was re-elected at each
general election until his retirement and spent two terms
as Taoiseach. Prior to entering politics Lynch had an
outstanding sporting career as both hurler and footballer,
winning 5 All-Ireland hurling titles, 7 Munster titles, 3
National Hurling League titles and 7 Railway Cup titles.
In football he secured 1 All-Ireland title, 2 Munster titles
and 1 Railway Cup title.

20 March 1957

'You look right and I'll keep an
eye out for anything coming
from the left!' Main Street,
Dungloe, Co Donegal.

2 April 1957

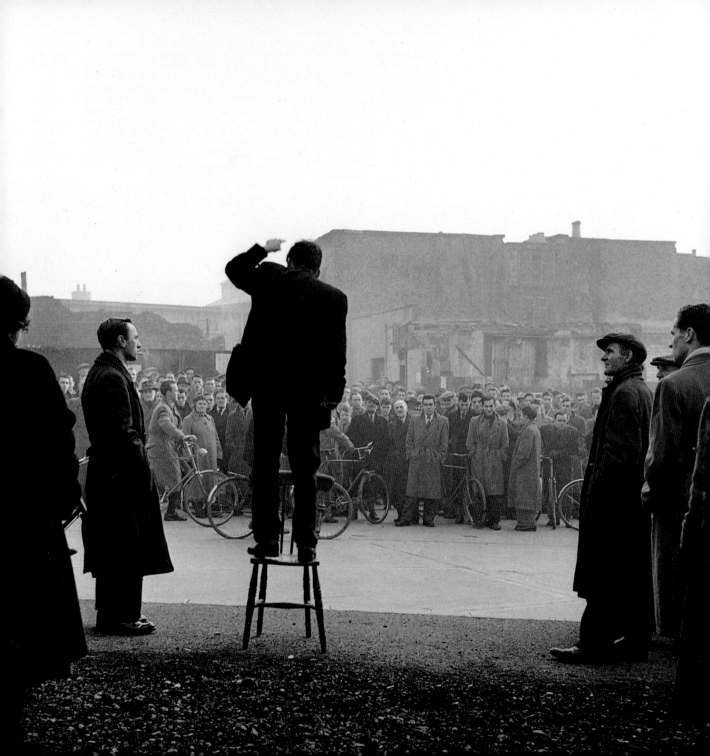

Unemployed building workers are addressed by one of their leaders outside Werburgh Street Labour Exchange. From that public meeting an Unemployed Protest Committee [UPC] was formed which organised marches and demonstrations to highlight the need for job creation.

3 April 1957

Champion Irish dancer Rory O'Connor, Albert Healy on the accordion, and Din Joe (Denis Fitzgibbon) during a performance of 'Take the Floor'. This hugely popular radio show, hosted by Din Joe, featured the O'Connor dancers, music, storytelling and 'house dancing' in which Din Joe used to call out the moves, such as 'take your partners, doh-see-doh; round the floor and off we go'. At the time no-one saw anything odd about listening to dancing on the radio!

11 April 1957

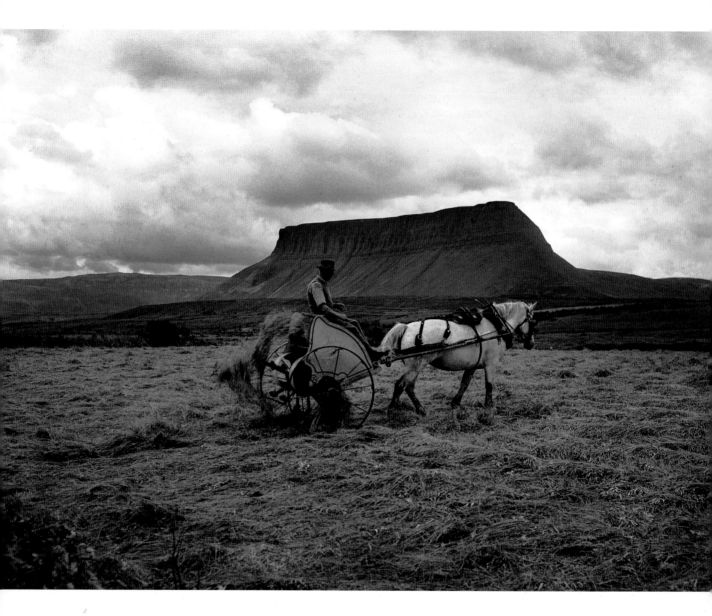

Saving hay at the foot of
Ben Bulben, Co Sligo.

25 April 1957

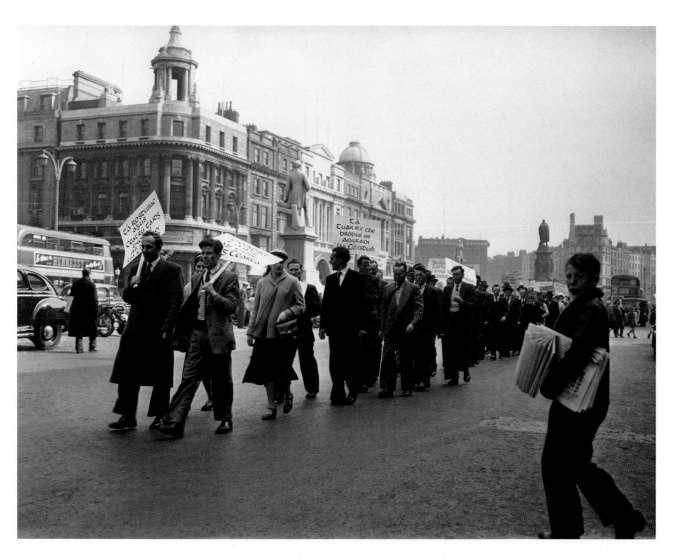

In the 1950s the roads through Dún Chaocháin, Co Mayo were in terrible condition. Having failed to draw the County Council's attention to the matter, a Kilcommon man, schoolteacher Harry Corduff, refused to pay his road taxes. He was imprisoned in Mountjoy Jail for a week. Public support for his cause was great and these are just some of the marchers from the Gaeltacht areas whose slogans say that they 'stand by Harry Corduff', and ask for his freedom.

25 April 1957

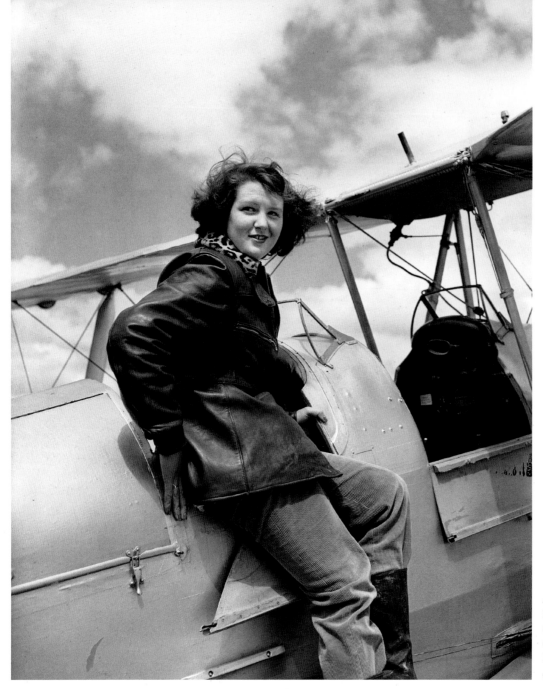

A 'magnificent lady in her flying machine' takes part in an air display at Weston, Leixlip, Co. Kildare

9 June 1957

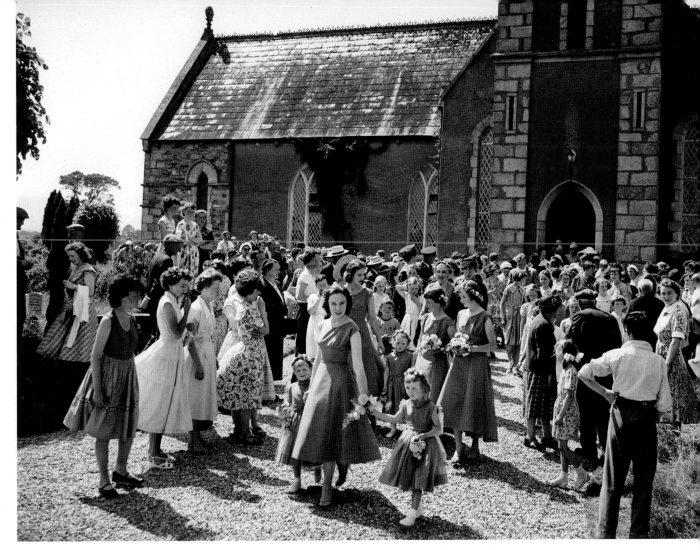

A happy wedding day in Co Wexford.

17 June 1957

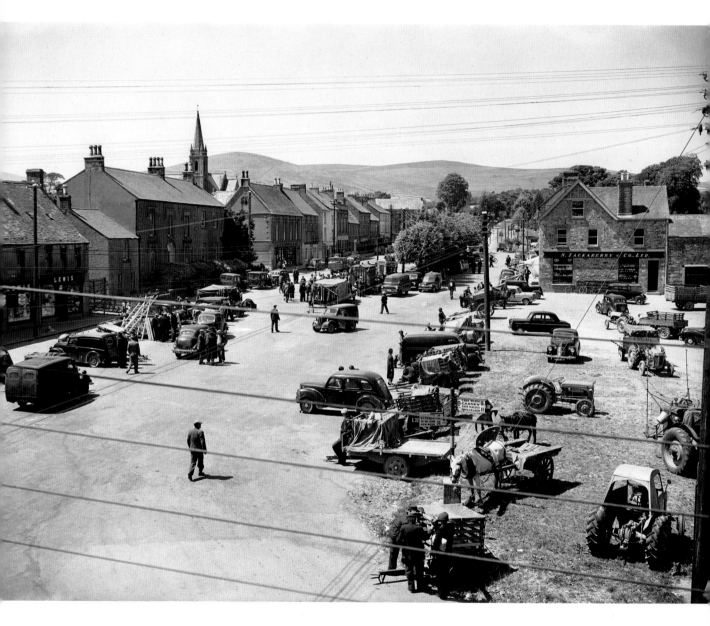

Market Day at Bunclody, Co Wexford.

17 May 1957

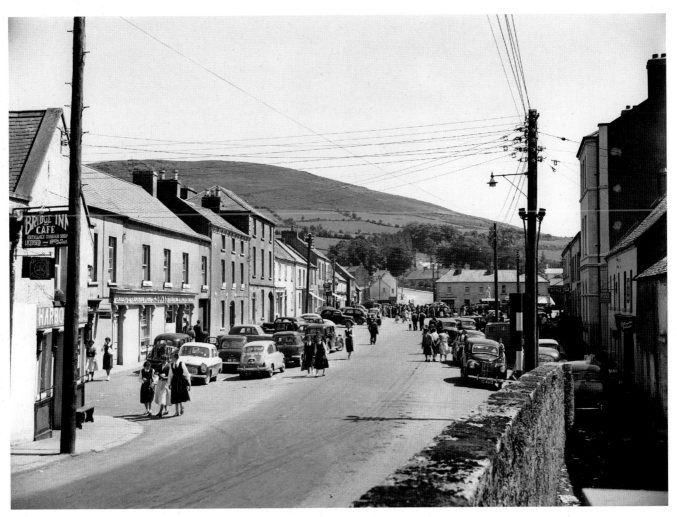

Baltinglass, Co Wicklow
on a fine summer's day.

17 June 1957

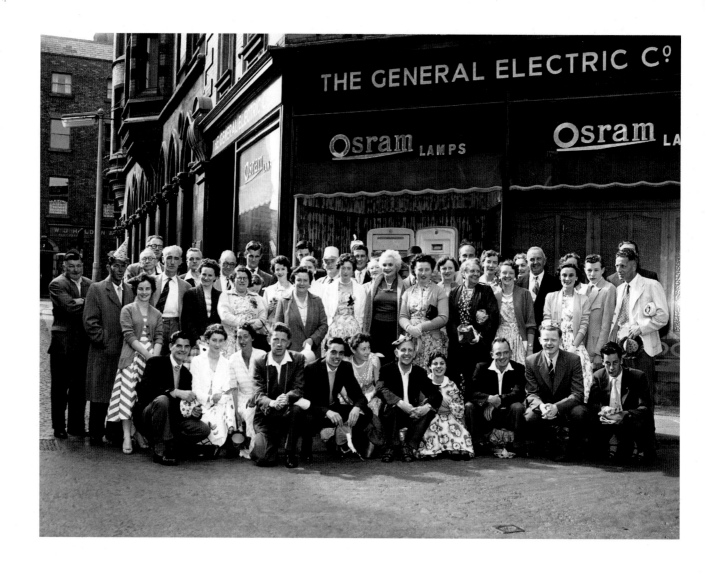

A grand day out! Employees of GEC all set for their
outing to Courtown Harbour.

22 June 1957

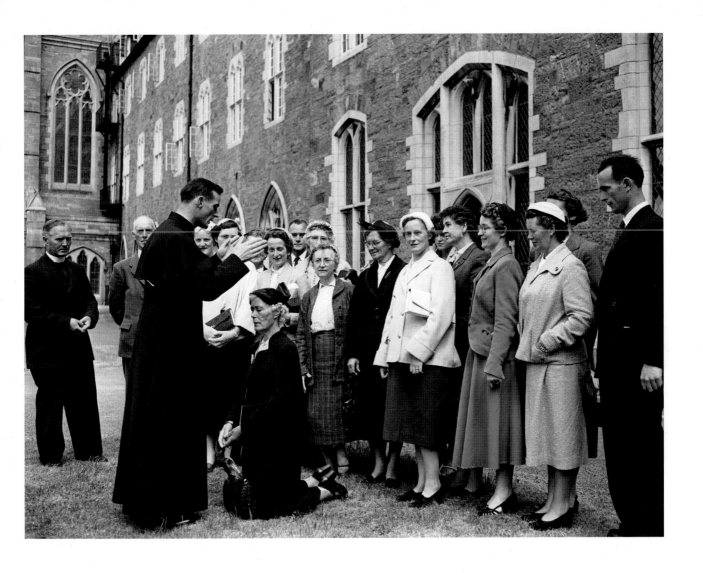

A newly-ordained priest gives his first blessing to
his mother at Maynooth.

23 June 1957

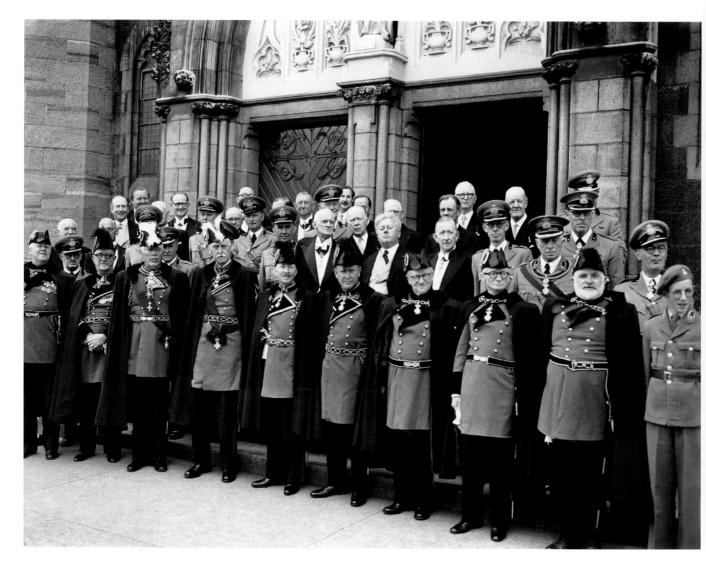

Members of the Order of Malta at Mass at St. Mary's Church, Haddington Rd. The origins of the Hospitaller Order of St John of Jerusalem, of Rhodes and of Malta – commonly referred to as the Knights of Malta, go back to the eleventh century. Today, the Order's mission is an exclusively humanitarian one, and it runs hospitals, medical centres, nursing homes, hospices, homes for the elderly, ambulance services and training in first aid in most countries in the world,

24 June 1957

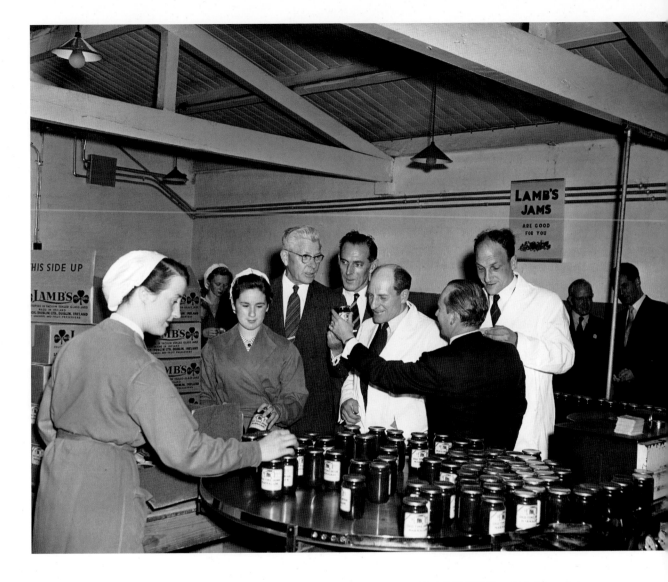

Fruitfield Old Time Irish Marmalade,
favoured by many for its coarsely cut
chunks of peel, being manufactured
at Lambs' Jam factory.

25 June 1957

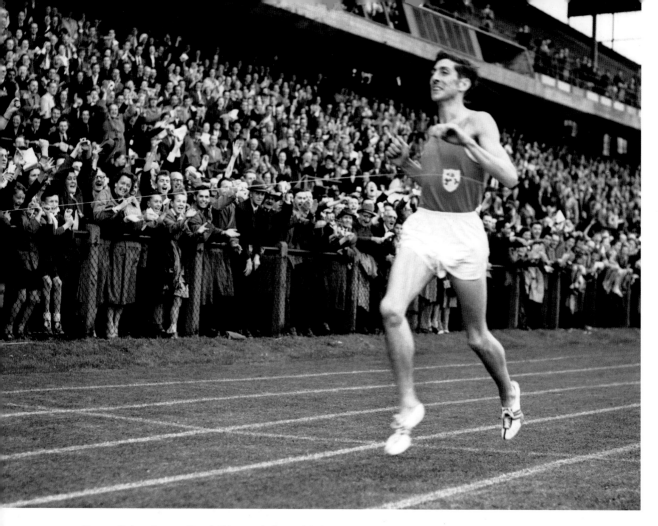

Ronnie Delany beating Derek Ibbotson before a delighted crowd at Lansdowne
Rd. In 1956 at Melbourne, Ibbotson won an Olympic bronze medal in the
5,000 metres, while Delany claimed gold in the 1500 metres. Ibbotson set a
new world record in the mile in 1957.

29 July 1957

Different styles among the judges
at the RDS Show.

6 August 1957

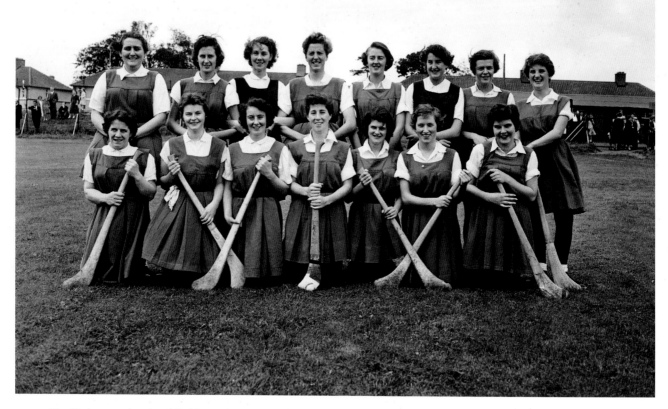

The Cork team who played Dublin in the
camogie semi-final at Parnell Park. Dublin won
5-4 to 1-3 and went on to defeat Antrim by a
two point margin in the finals.

8 September 1957

A bit of excitement caused by the tipping
over of an overloaded truck belonging to
Boxwood timber merchants.

25 September 1957

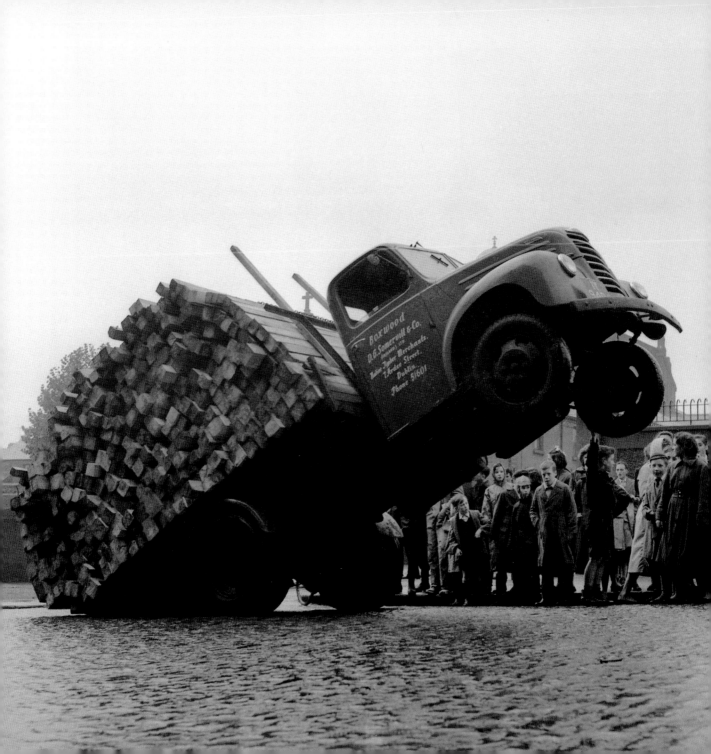

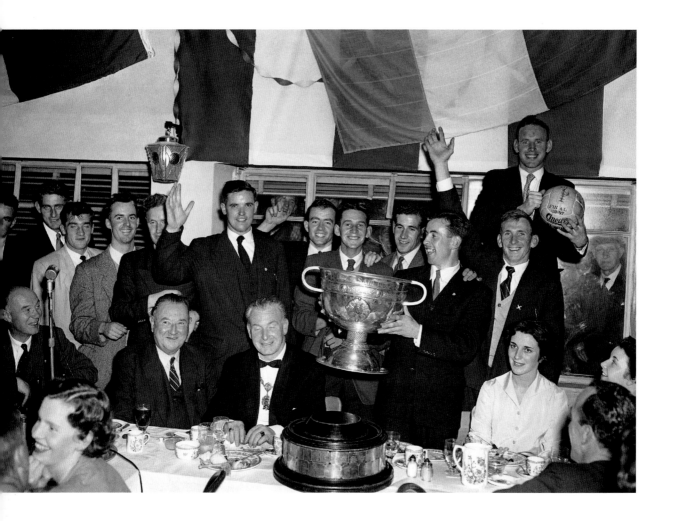

The Louth team and their supporters
celebrate with the Sam Maguire Cup
after defeating Cork in the All Ireland
Final with a score of 1-9 to Cork's 1-7.
The attendance at the match was 72,732.
This was Louth's third All Ireland win, the
others having been in 1910 and 1912.

22 September 1957

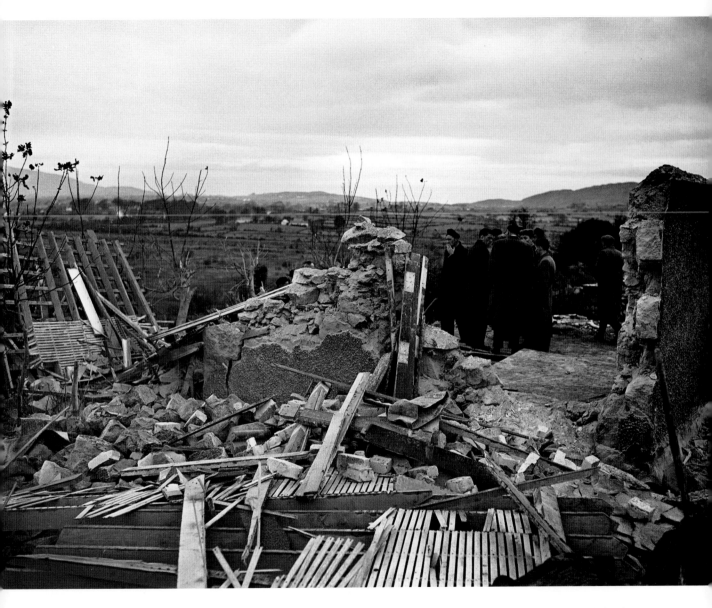

Explosion at cottages on the Louth/Armagh border.
Part of the IRA's Border Campaign of guerilla warfare.

11 November 1957

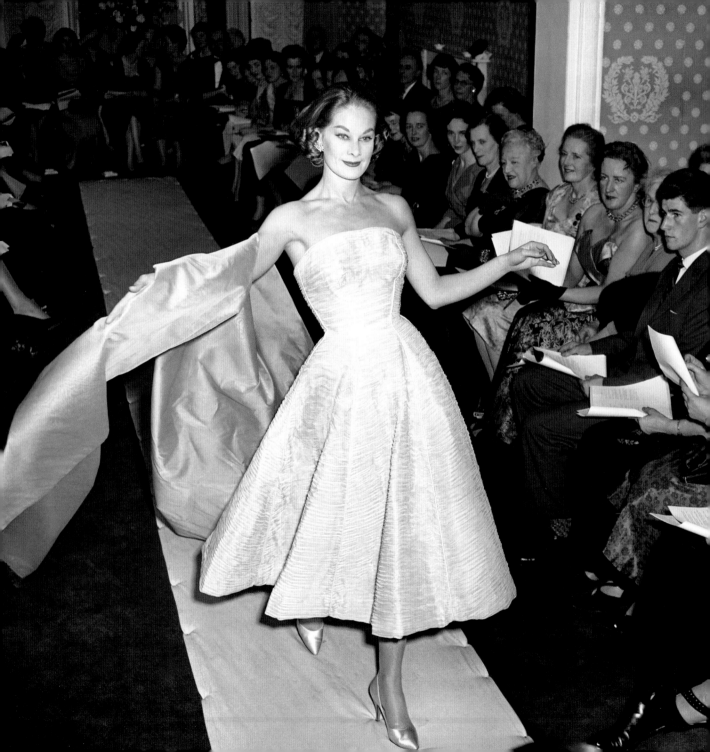

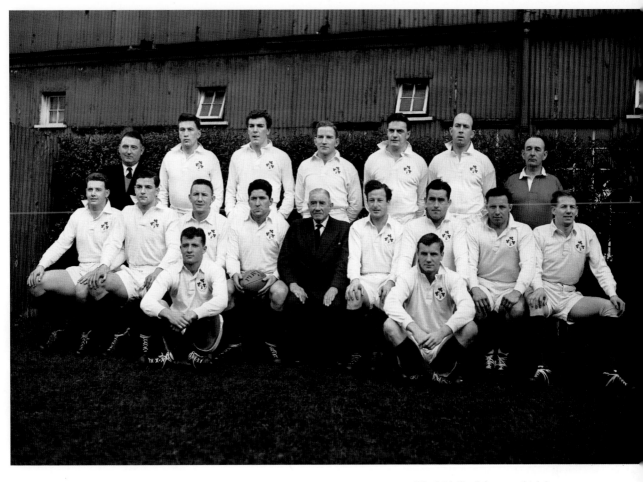

A model displays an evening dress from the Sybil Connolly
collection at her new premises on Merrion Square. The
designer's clothes were sought after in the United States and
she had an impressive list of clients from prominent families
such as the Rockefellers, Mellons and Duponts, to famous
actresses of the day. Jacqueline Kennedy wore a Sybil Connolly
creation when she sat for her official White House portrait, and
visited the designer in Ireland.

17 January 1958

The Irish Rugby team which beat
Australia 9-6 in Dublin. This was
the first time a major touring
team had been defeated.

18 January 1958

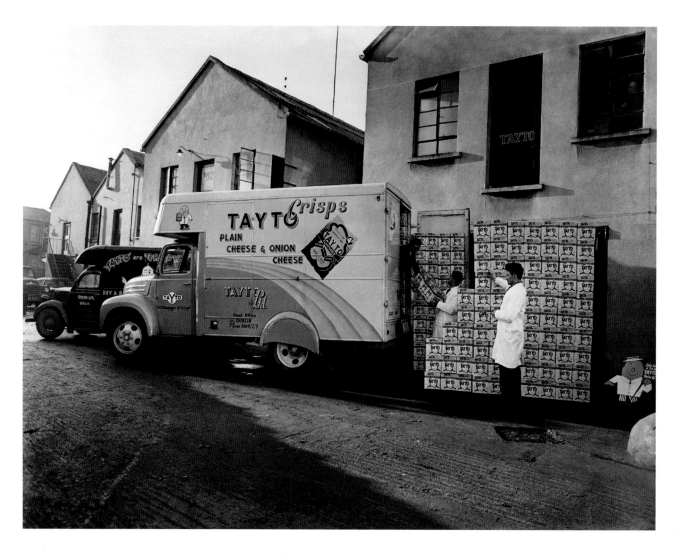

A Tayto van being loaded. In 1954 Joe 'Spud' Murphy began what is today's largest snackfood company with just two rented rooms off Moore Street, Dublin. At the time Tayto crisps sold for 4 pence per bag! The bags were hand-glued with a tiny paintbrush to guarantee freshness. Joe also invented the world renowned Cheese & Onion flavour. In 1954, Tayto sold 347 packs per day. Today, Tayto sells over 525 packs a minute!

31 January 1958

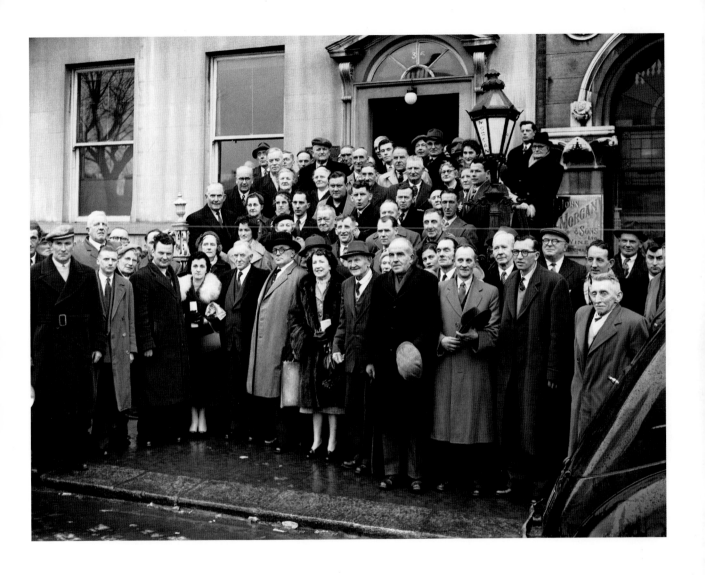

The Fine Gael Ard Fheis outside the Engineers' Hall.

4 February 1958

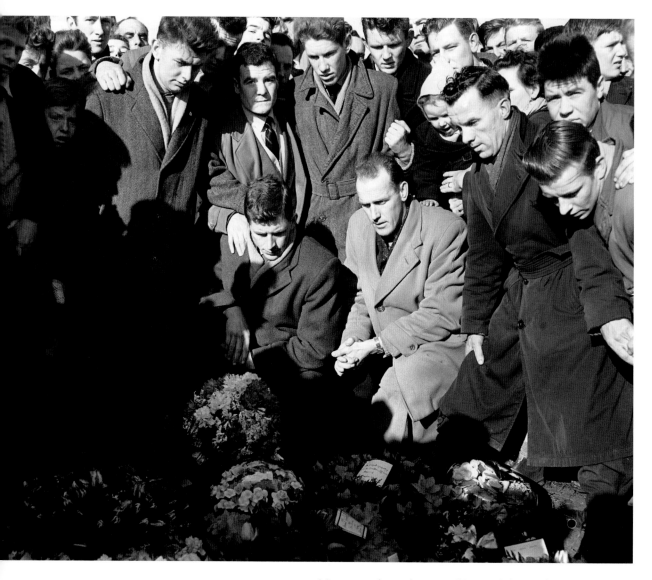

Mourners gather at the grave of Liam Whelan in Glasnevin cemetery. The former Home Farm player from Cabra was one of the famed Manchester United 'Busby Babes' to die in the Munich Air Disaster on 6 Feb 1958. He was 22 years old.

19 February 1958

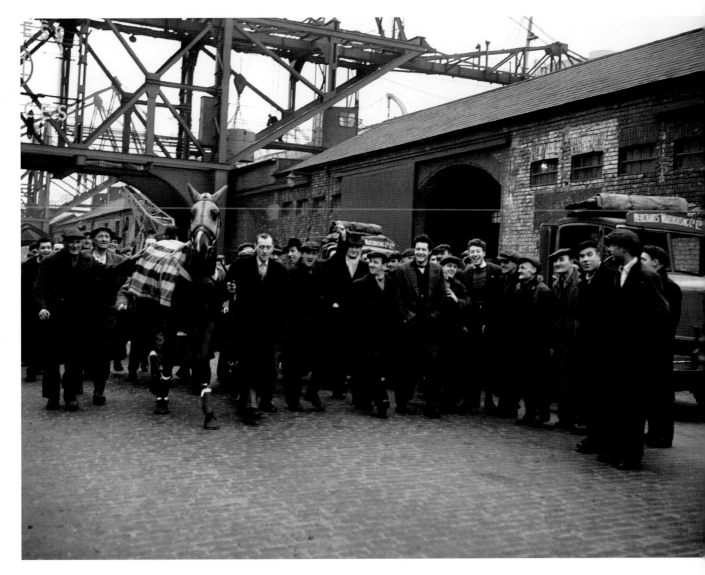

Mr What arrives home after winning the English Grand
National. He was ridden by Arthur Freeman and had a starting
price of 18/1. *Mr What* was bred by Mrs Barbara O'Neill of
Rathganny, Co Westmeath.

28 March 1958

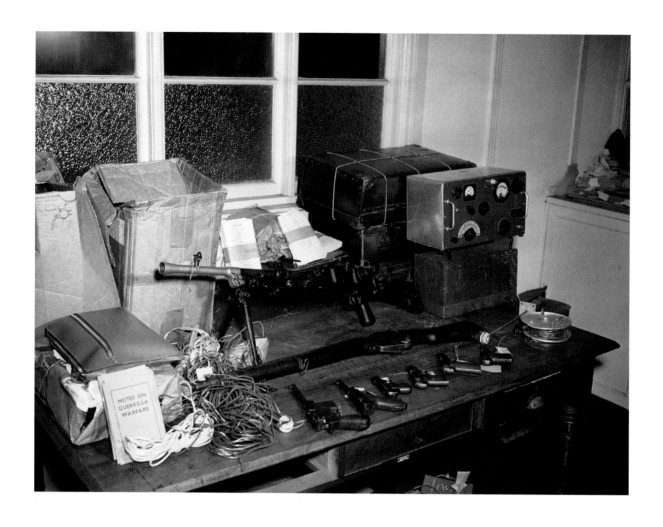

Arms and radio transmitter seized by Gardai, along with
a booklet 'Notes on Guerrilla Warfare'.

16 April 1958

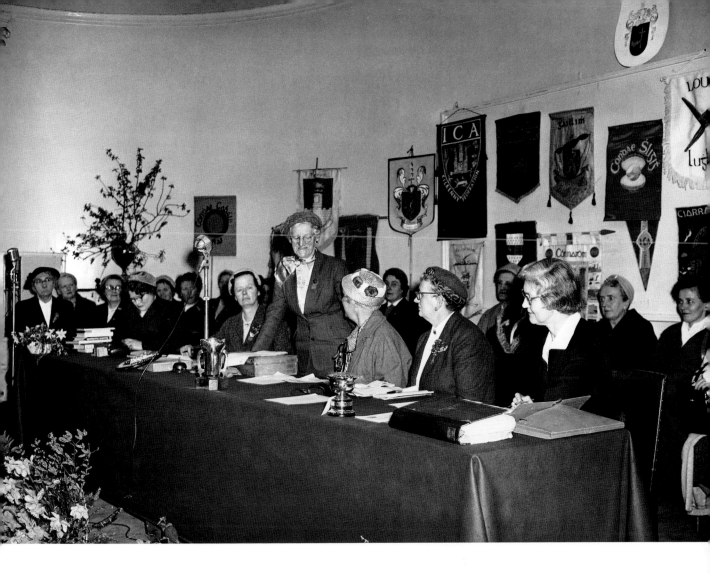

A meeting of members of the Irish Countrywomen's Association from various counties (see banners on wall of County Guilds). The Association was founded in 1910 and now has over 11,000 members.

18 April 1958

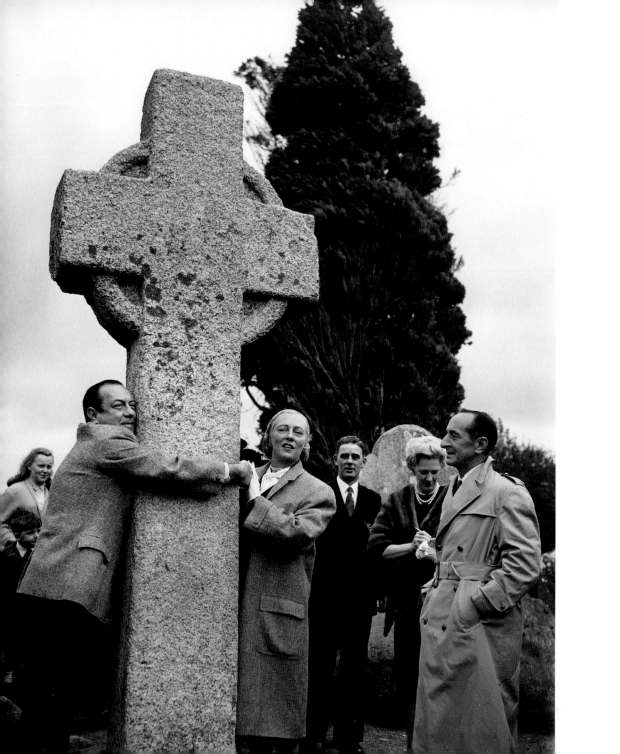

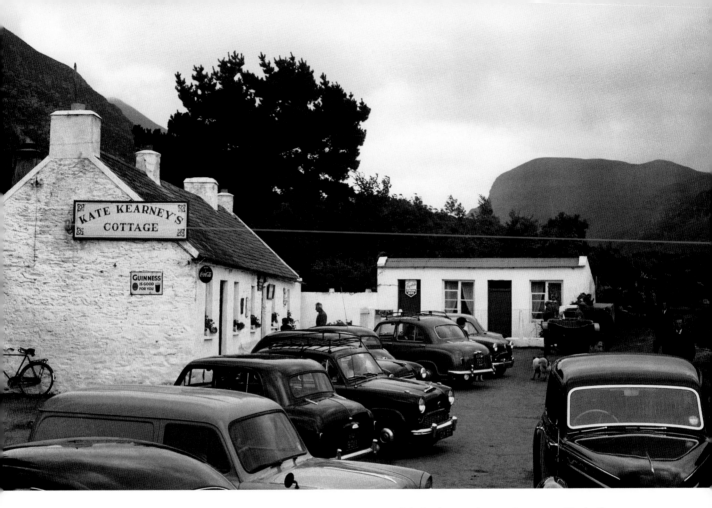

'Modern' cars and a jaunting car outside the famous
Kate Kearney's Cottage in Killarney, Co Kerry.

5 May 1958

New York Mayor Robert Wagner gets to grips with an
ancient Celtic Cross at Glendalough,
Co Wicklow.

27 April 1958

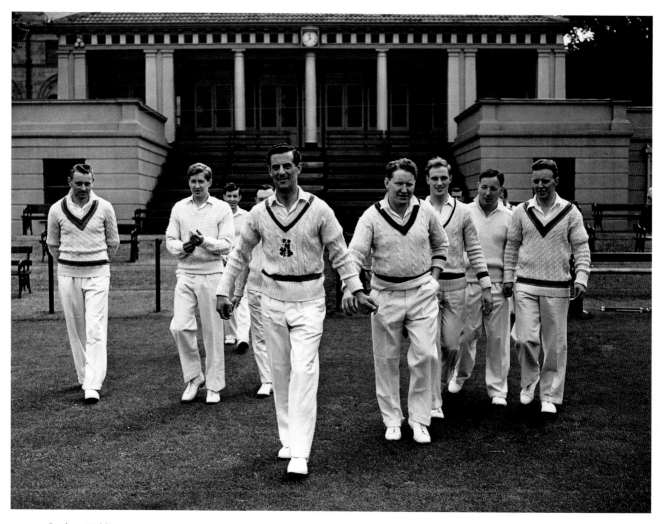

Cricket: Dublin University vs. North of Ireland
at Trinity College grounds.

9 June 1958

Italian-American prima ballerina and model Enrica 'Ricki'
Huston (née Soma) in Co. Galway. The fourth wife of film
director John Huston, she was the mother of actor Anjelica
Huston. She died in a car crash in France. in 1969, aged 39.

23 June 1958

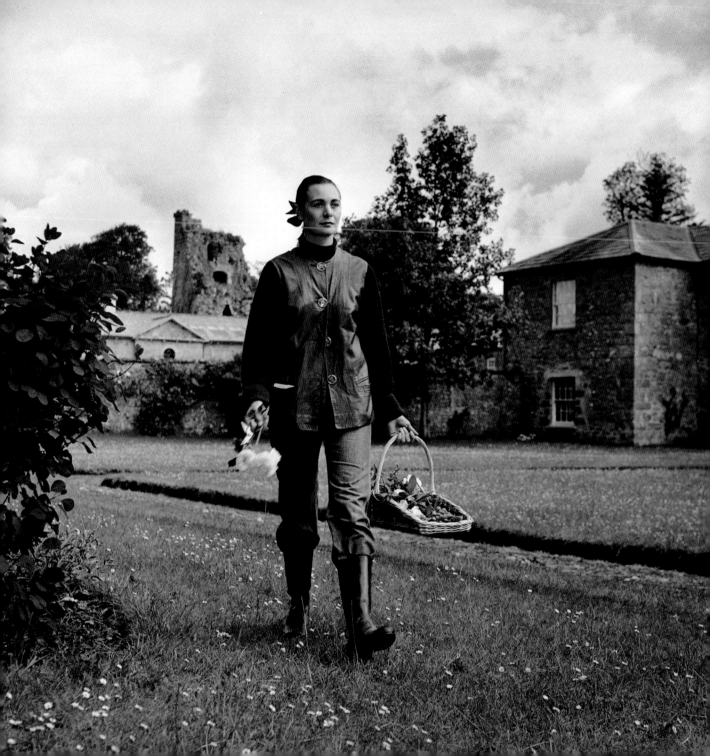

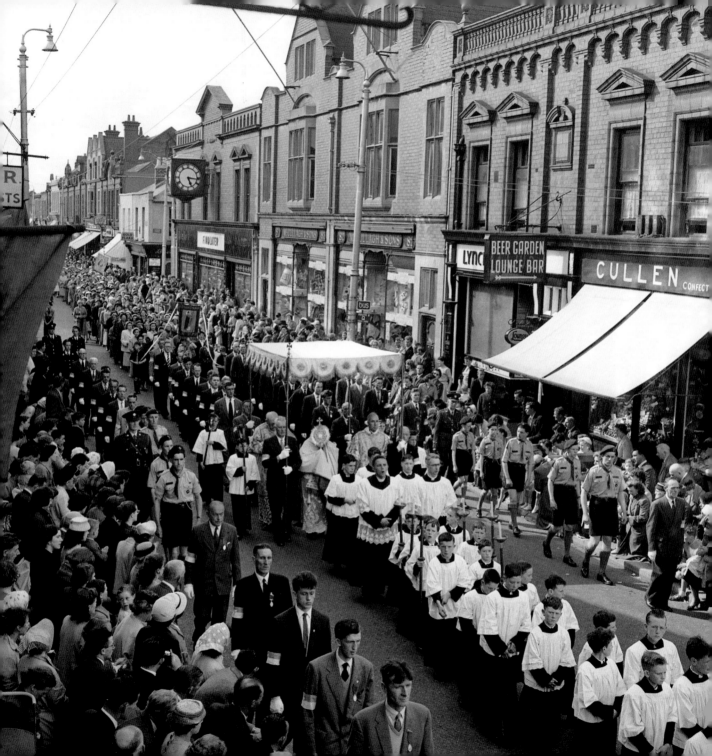

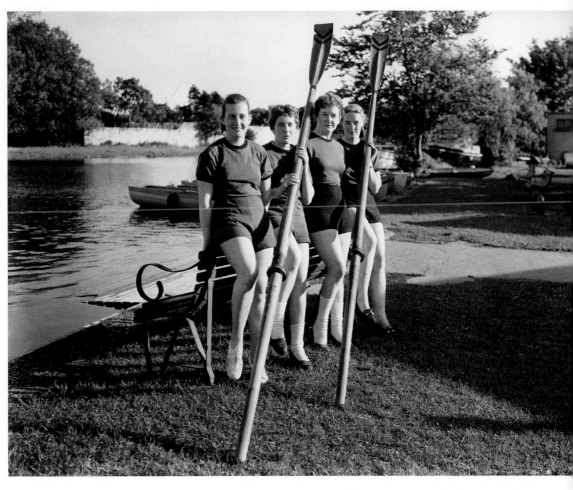

An all-female rowing crew in Galway.

26 June 1958

The Corpus Christi procession in Dún Laoghaire. Processions such as this were held throughout the country on the feast day and involved clergy and laity, including Scouts, Girl Guides, the Legion of Mary etc. The central focus was the host, displayed within an ornate gold monstrance, seen here being carried by a robed priest, under the canopy.

25 June 1958

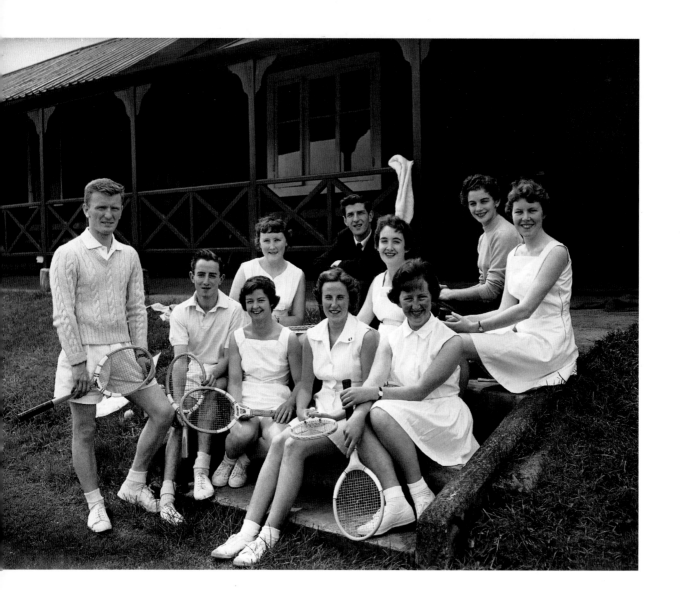

Impeccably-turned out competitors in the Inter-university Championship
Tennis. University College Cork vs. Queen's University Belfast.

27 June 1958

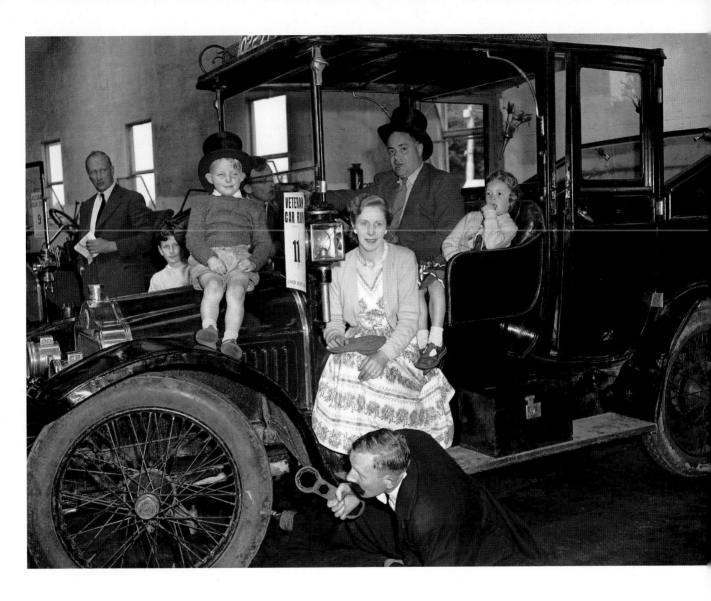

Veteran car run from Donnybrook to Bray. Mother
holds his flat cap while the mustachioed mechanic takes
a spanner to the wheel.

28 June 1958

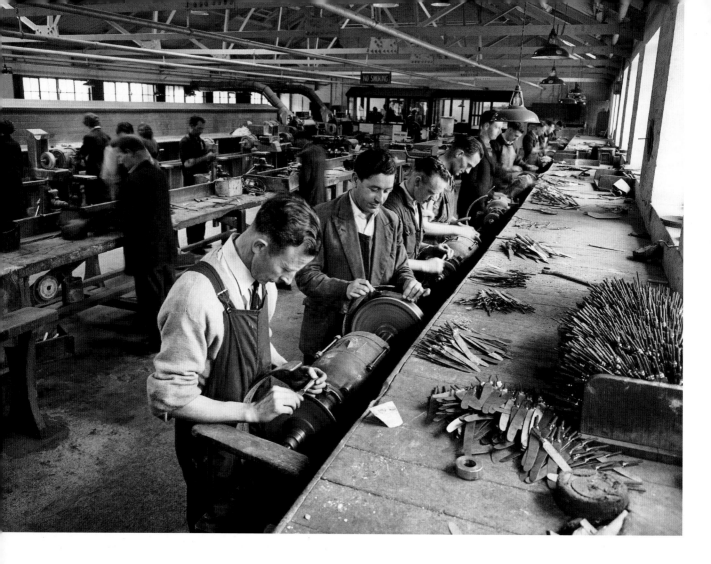

Newbridge cutlery being manufactured. A full set, called
a 'canteen', in either Kings pattern or Celtic pattern
would have been a very desirable wedding gift at the
time, and, although Newbridge have branched out into
jewellery and other lines, this cutlery is still sold today.

10 July 1958

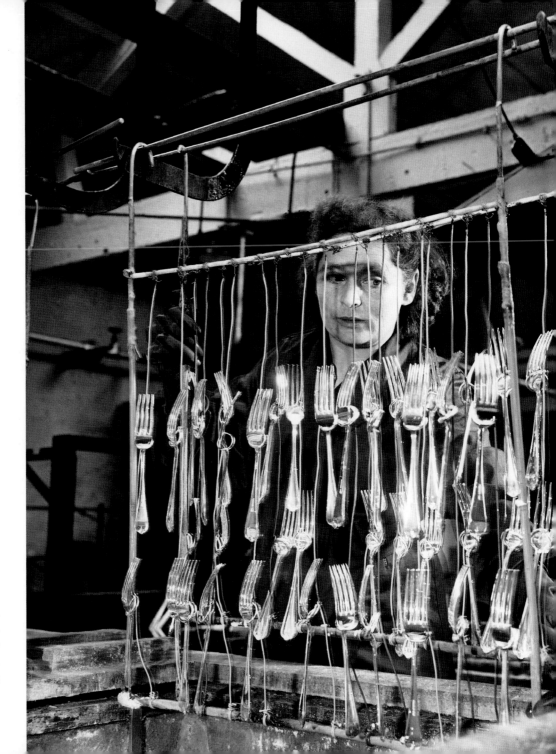

The cutlery
is finished by
dipping in silver
plating (EPNS).

10 July 1958

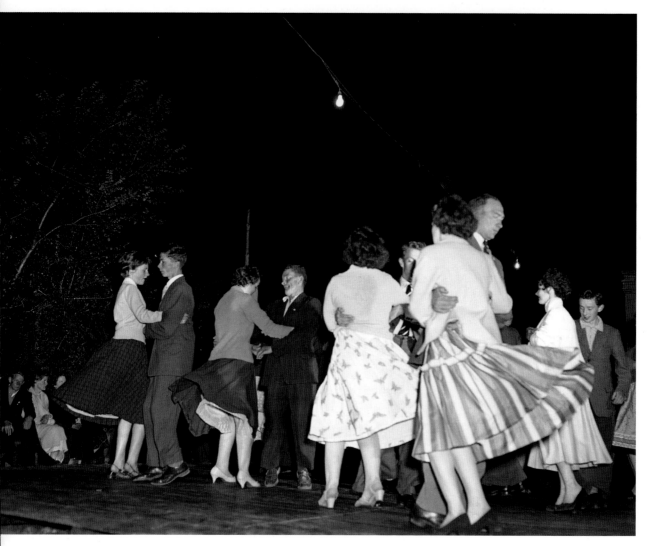

Dancing at the crossroads, Kilcoran, Co Tipperary.
10 July 1958

A rural family pose for the camera.
15 July 1958

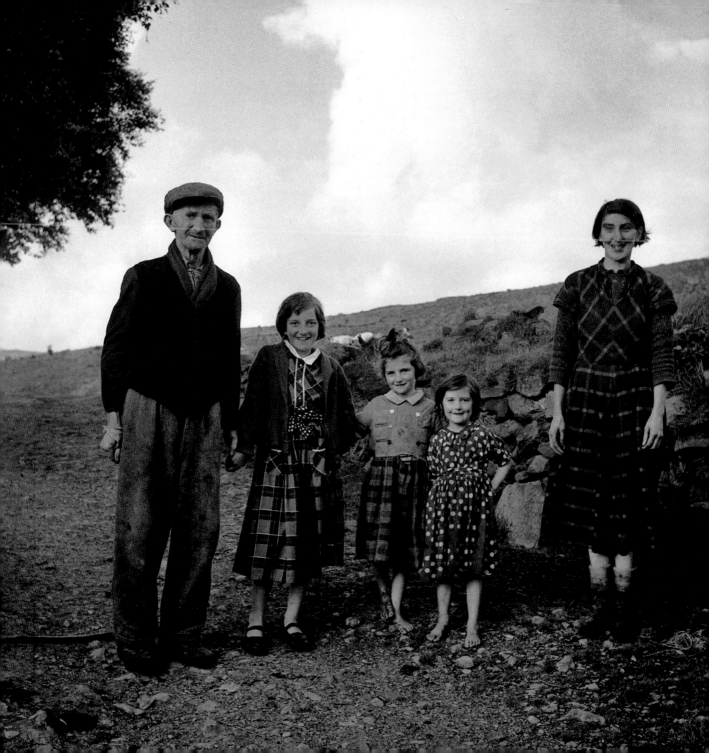

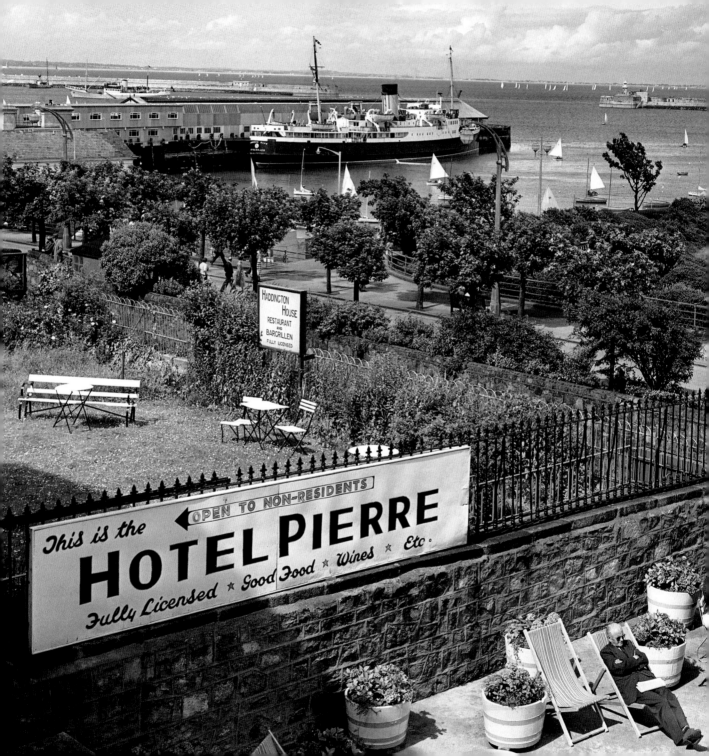

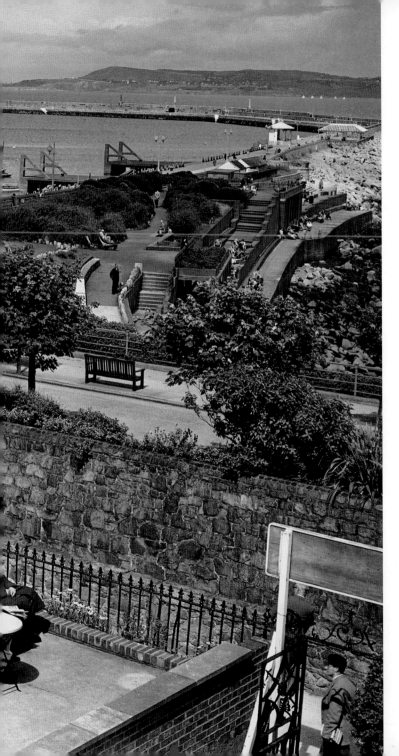

Sailing or snoozing, there were many ways of enjoying a summer's day at Dún Laoghaire harbour.

26 July 1958

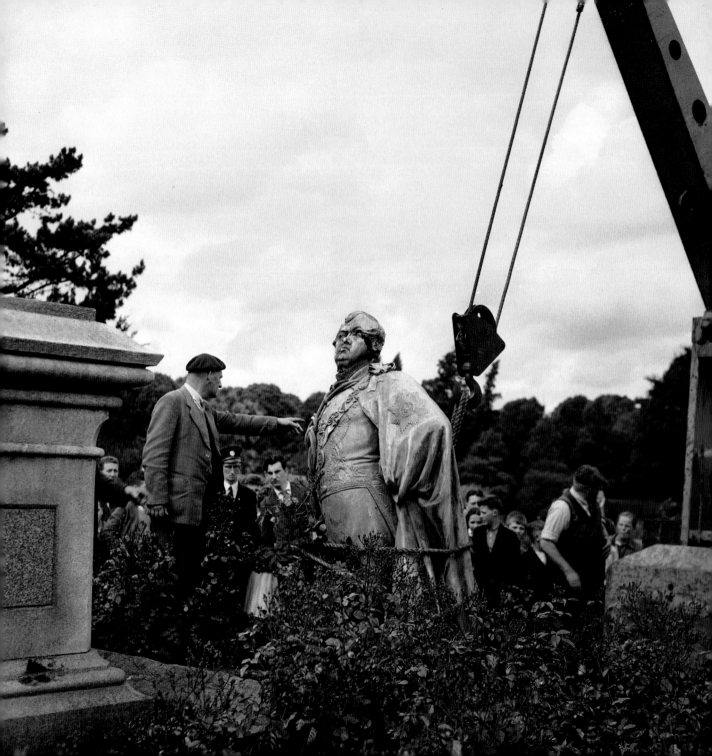

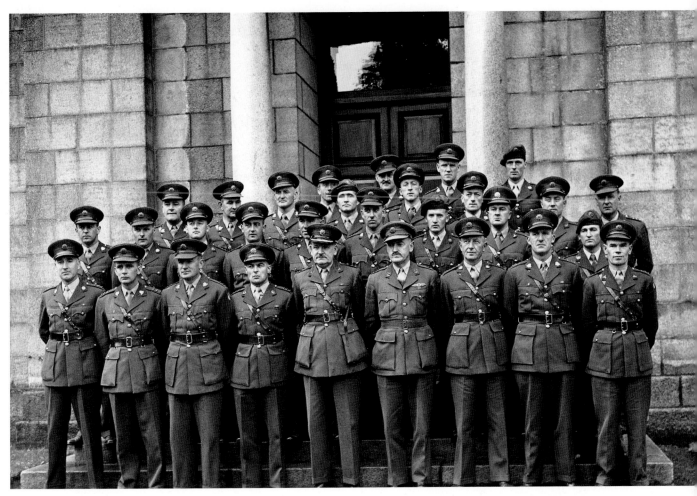

Army officers outside GHQ before heading for the Lebanon. Since joining the United Nations in 1955, the Army has been deployed on many peacekeeping missions. The first of these missions took place in 1958, when a small number of observers were sent to Lebanon.

23 September 1958

What's left of the statue of Lord Carlisle is towed away from its plinth in the Phoenix Park, Dublin, after being blown up by militant republicans. George William Frederick Howard, the 7th Earl of Carlisle, had served as Lord Lieutenant of Ireland on two separate occasions in the 1850s and 60s.

25 July 1958

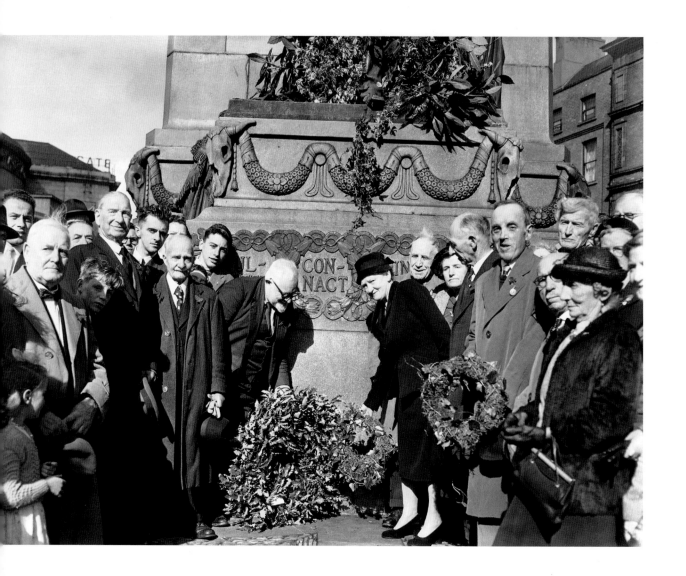

Supporters of Charles Stewart Parnell gather at his
statue in O'Connell Street to leave wreaths on the
anniversary of his death. Several wear ivy leaves in
their lapels as did mourners at Parnell's funeral,

6 October 1958

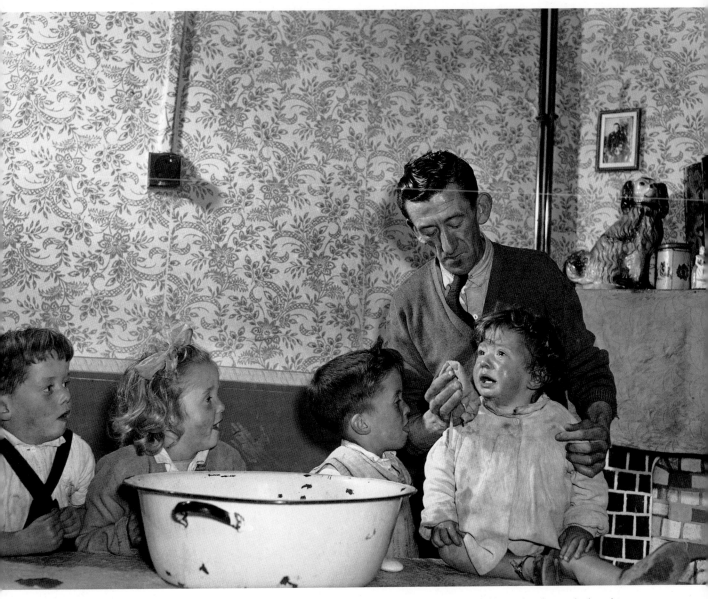

The tin basin was the main washing facility for children when houses had neither baths nor showers. This family, which included a number of twins, lived in Ballyfermot, Dublin.

12 October 1958

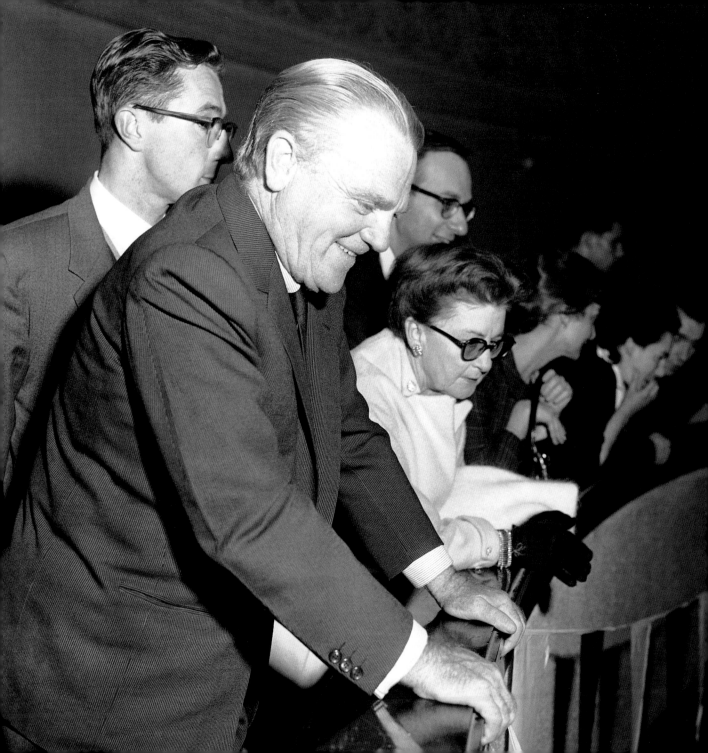

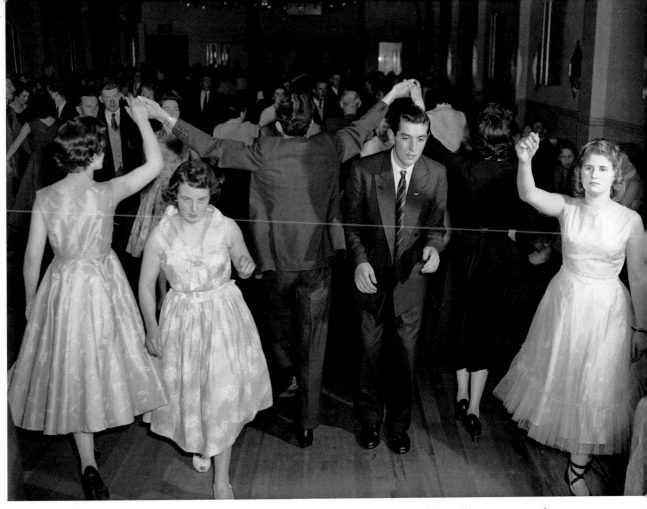

Céilí at the Mansion House. There were many dance types, apart from reels and jigs, and these couples, who would have been facing each other in two sets of four, were probably dancing 'The Siege of Ennis' or 'The Walls of Limerick'.

19 October 1958

Film star Jimmy Cagney, a noted 'hoofer' himself, enjoys watching the dancing at a Gael-Linn Céilí.

October 1958

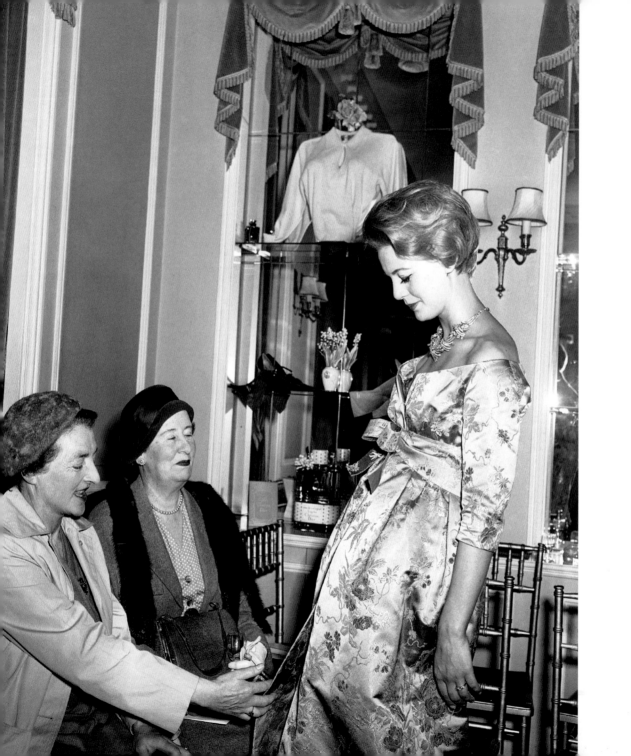

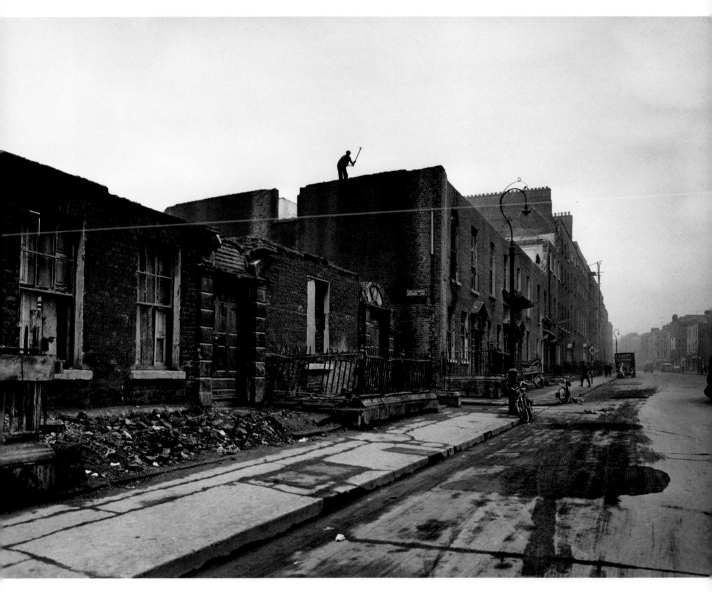

'Just feel the quality!' Admiring ladies at a Christian Dior fashion show in Brown Thomas.

13 October 1958

A worker is silhouetted against the sky as he takes part in the demolition of tenement buildings in Dublin. The sign on the side of the building identifies it as Dominick Lane.

17 November 1958

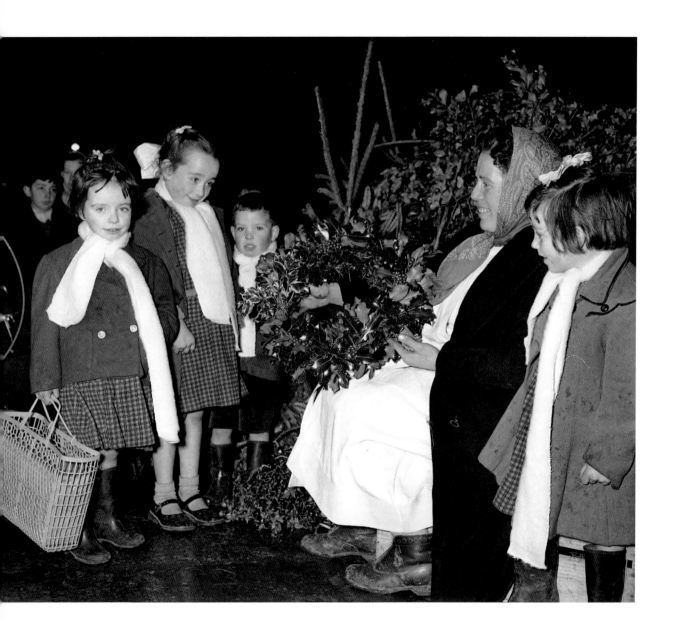

Berried holly wreaths for sale on Henry Street.

15 December 1958

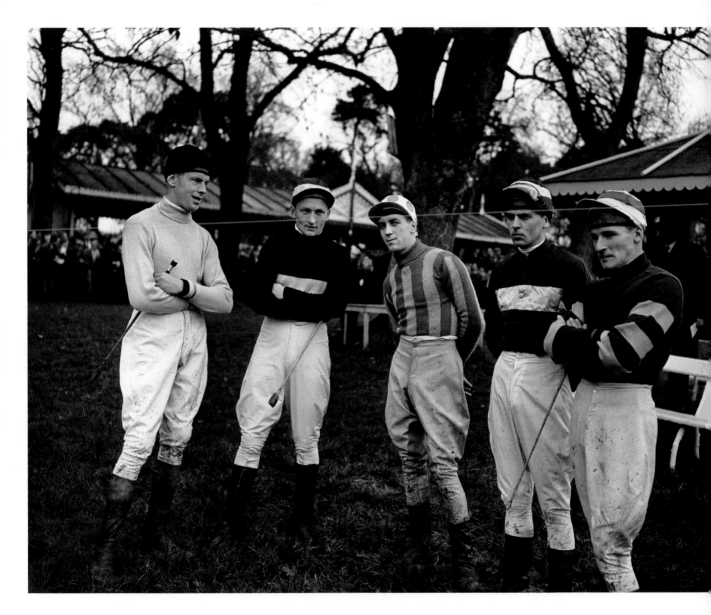

Jockeys discuss their rides at the annual post-Christmas racing
at Leopardstown. Pat Taaffe is left of picture.

30 December 1958

131

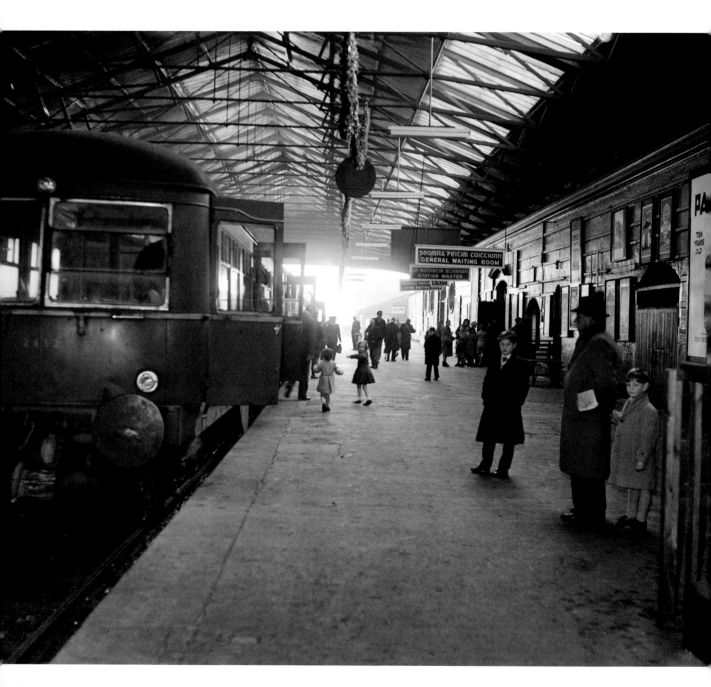

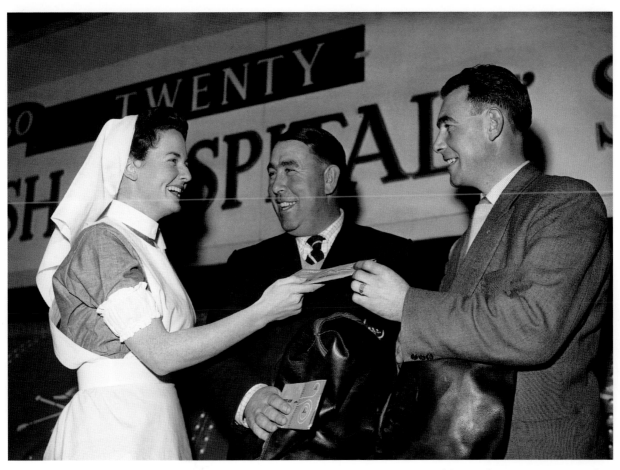

A Hospital Sweepstakes nurse presents air tickets to Canada to golfers Harry Bradshaw and Christy O'Connor.

21 January 1959

'All aboard!' The last train about to leave Harcourt Street station before the line closed down. The *Irish Independent* reported that the train left the 100-year-old terminus at 4.25pm. 'Among the 500 passengers, there were young children who were having their first and last train journey on that route. Hundreds of people gathered at the station and outside to watch the end of the service. As the train moved out, fog signals exploded and passengers waved to the crowds on the platform.'

31 December 1958

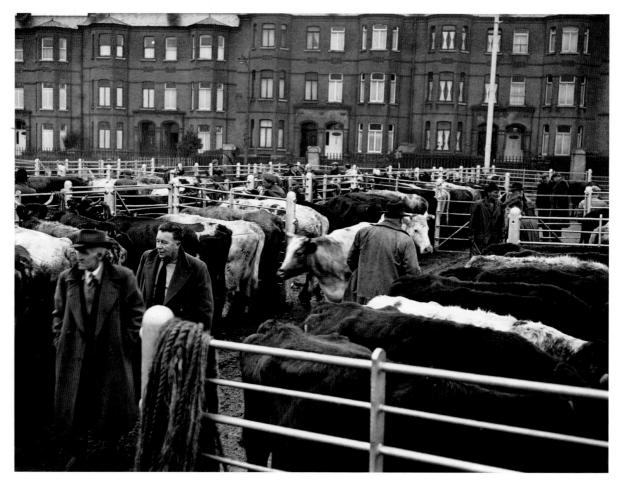

Experienced eyes are cast over the beasts on sale at
the cattle market in Prussia Street, North Circular
Road, Dublin.

21 January 1959

A competitor checks the depth of her furrows at the
Queen of the Plough Championships, Kilkenny.

29 January 1959

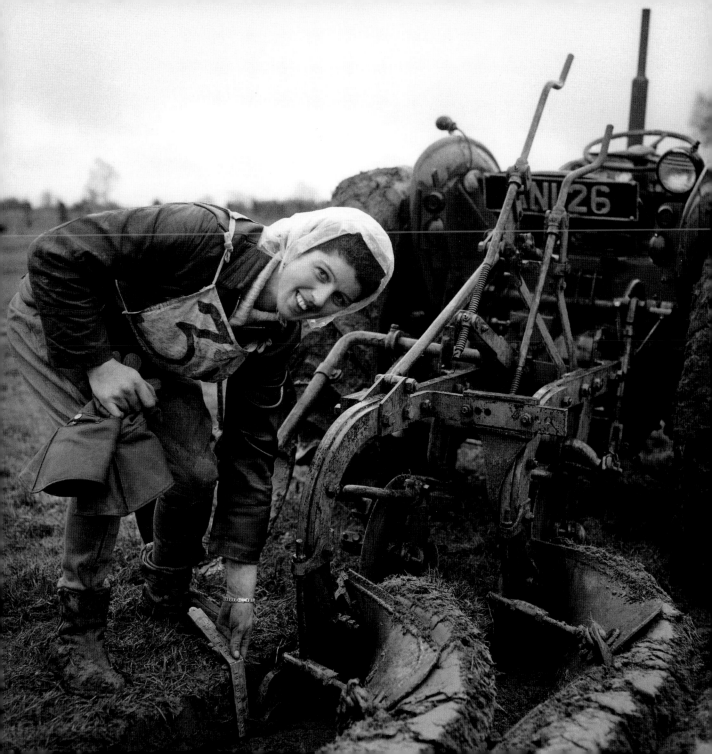

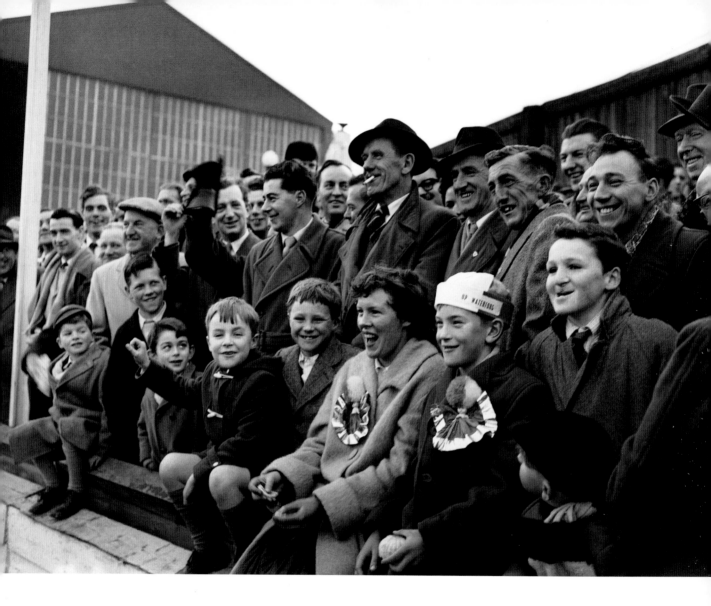

Waterford supporters at Harold's Cross. The
county colours in the paper hats 'ran' in the rain,
leading to an interesting variety of coloured heads
on the way home from a match!

17 February 1959

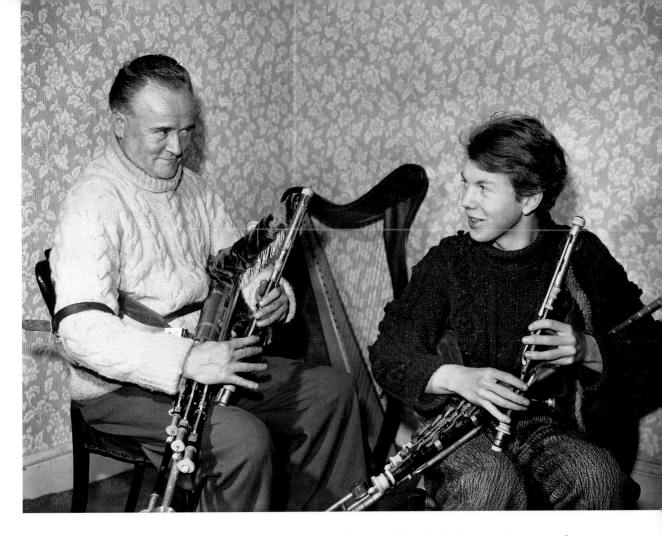

Piper Leo Rowsome (left) with the Hon. Garech Browne, often
known as Garech de Brún, a member of the titled family of
Oranmore and Browne in the West of Ireland. He has been a
leading proponent for the revival and preservation of traditional
Irish music through his record label, Claddagh Records, which
he founded in 1959. The first album it produced was the
classic *Rí na bPíobairí* (King of the Pipers) by Leo Rowsome.
The second Claddagh album was The Chieftains, the very first
recording of the now world-famous traditional group.

29 February 1959

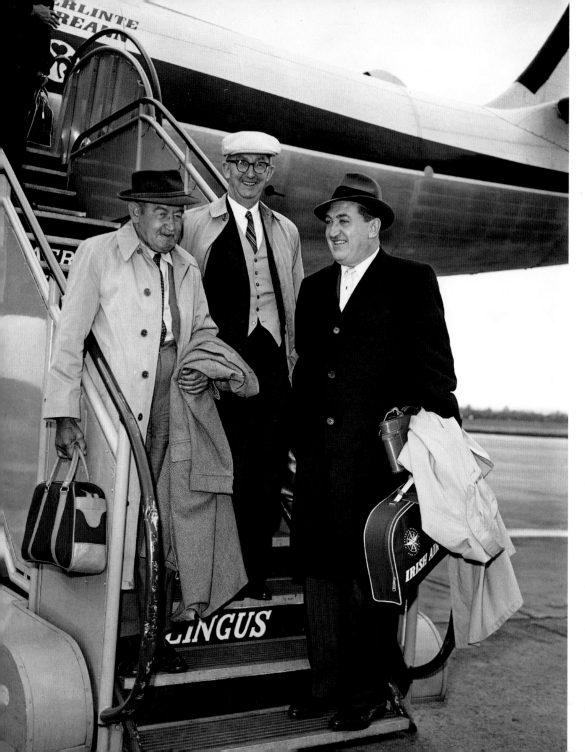

Arrival from New York of Barry Fitzgerald, John Ford and JJ O'Leary. Dublin-born Fitzgerald had a long and successful career in Hollywood in films such as *Going My Way* and *How Green Was My Valley.* Ford was famous for his Westerns such as *Stagecoach, The Searchers,* and adaptations of such American novels as *The Grapes of Wrath,* as well, of course as *The Quiet Man* (1952). He won four Academy Awards for Best Director (1935, 1940, 1941, 1952).

2 May 1959

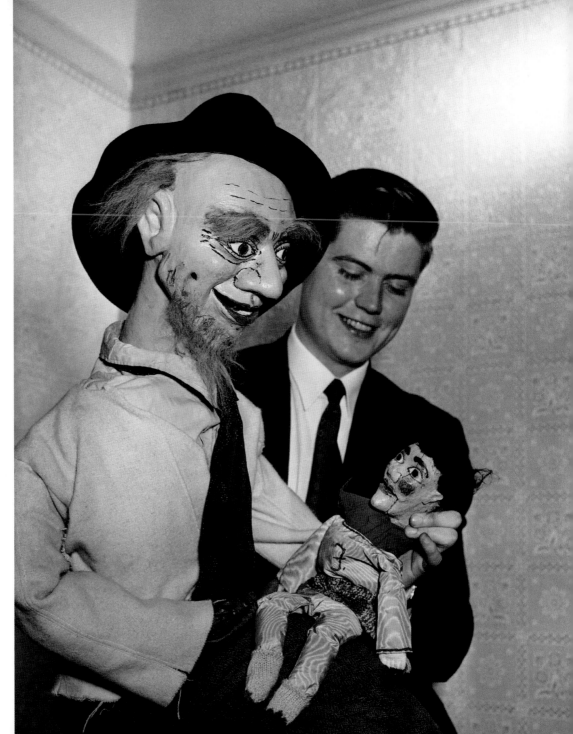

Irish ventriloquist/
puppeteer and
broadcaster George
Boyle, better known as
Seoirse Ó Baoghill, with,
on left, Beartlai, and
right, Toby. They later
had a programme on
RTÉ called 'Seoirse agus
Beartlai'.

13 May 1959

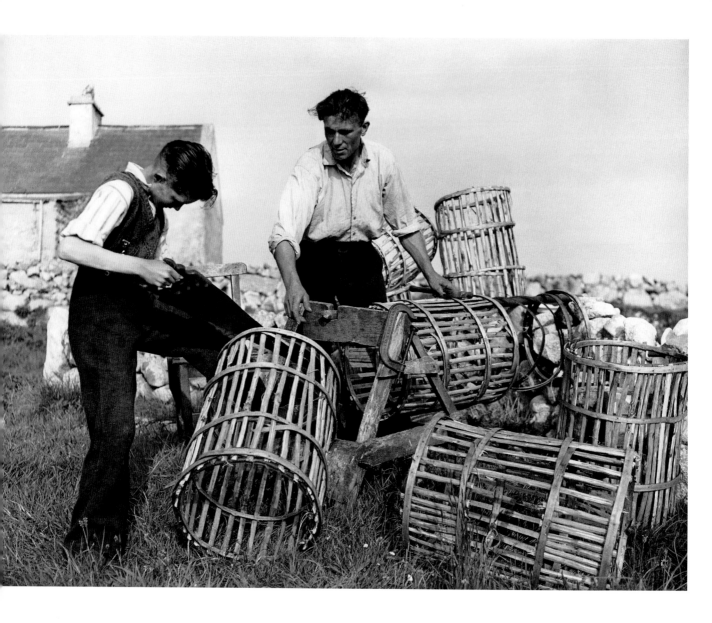

Making and repairing lobster pots in Carna,
Connemara.

15 May 1959

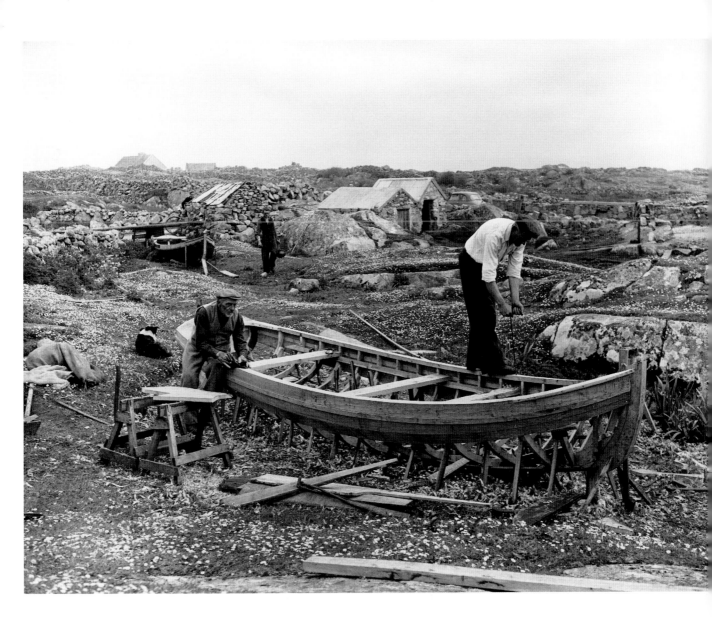

The Cloherty family building boats in Carna.

15 May 1959

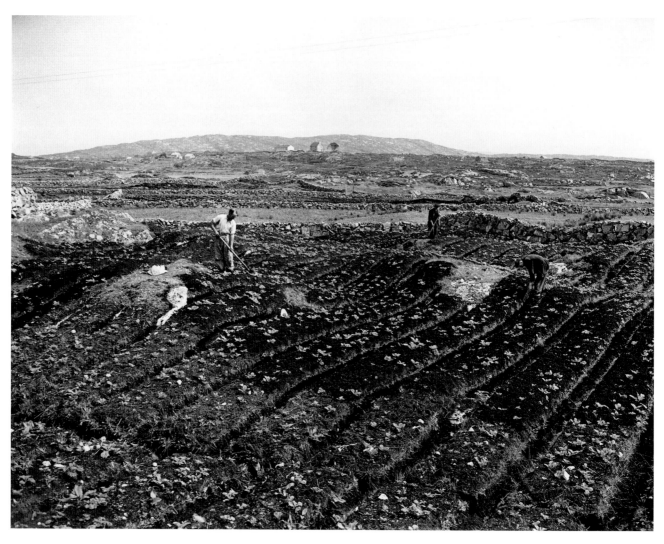

Farming was tough amongst the stony ground of
Connemara. Here the system of 'lazy beds' was used.

16 May 1959

Many people lost money in the Shanahan's Stamp auctions
scheme, run by Dr Paul Singer. This robbery at Shanahan's
in Dún Laoghaire in 1959 resulted in the disappearance of
an uninsured stamp collection worth a staggering half-a-
million pounds. This caused panic among investors who
besieged the auction house looking for their money.

30 May 1959

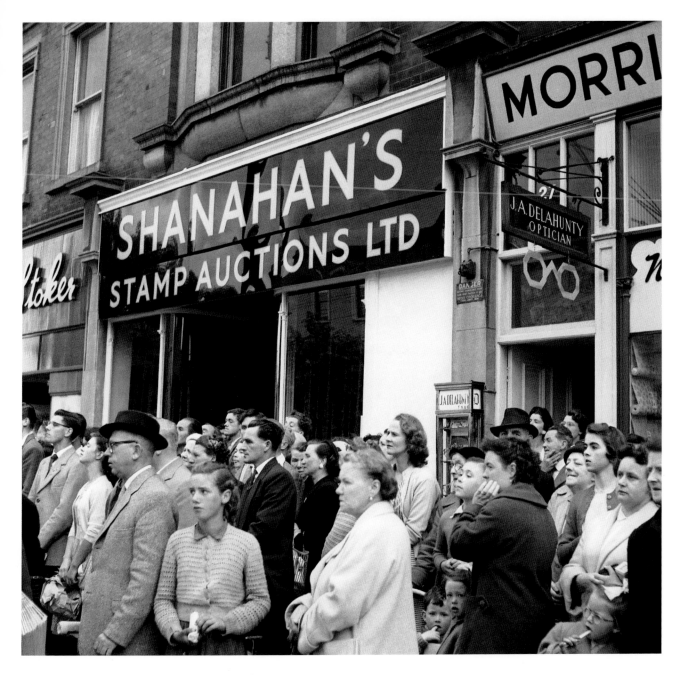

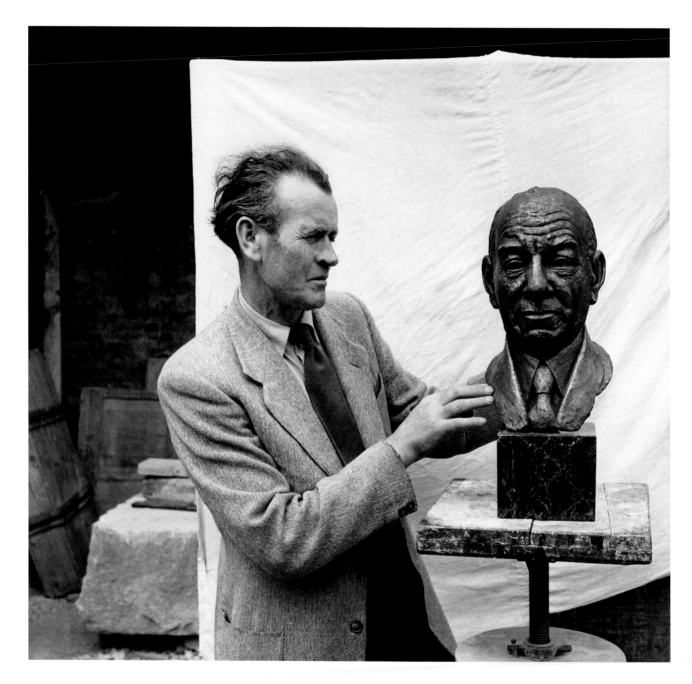

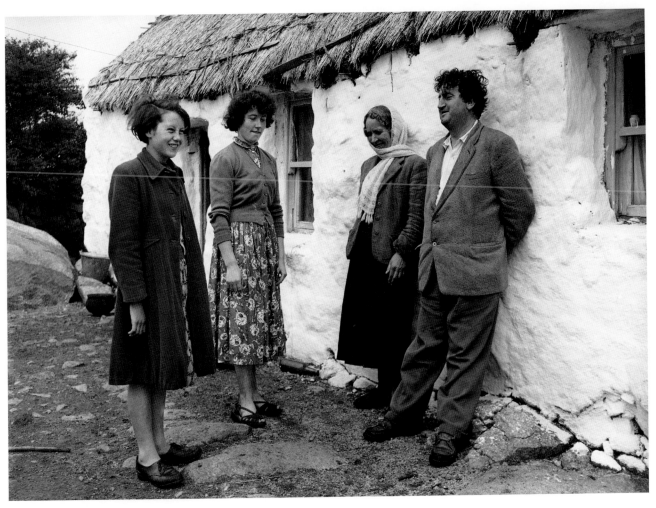

Brendan Behan and his wife, Beatrice, relax against a white-washed thatched cottage on a visit to Connemara.

10 June 1959

Noted sculptor Seamus Murphy, Cork, achieved a fine reputation for ecclesiastical limestone statues and portrait heads. Here he is pictured with a head of President Seán T Ó Ceallaigh, which stands with busts of the other Irish Presidents in Aras an Uachtaráin.

30 May 1959

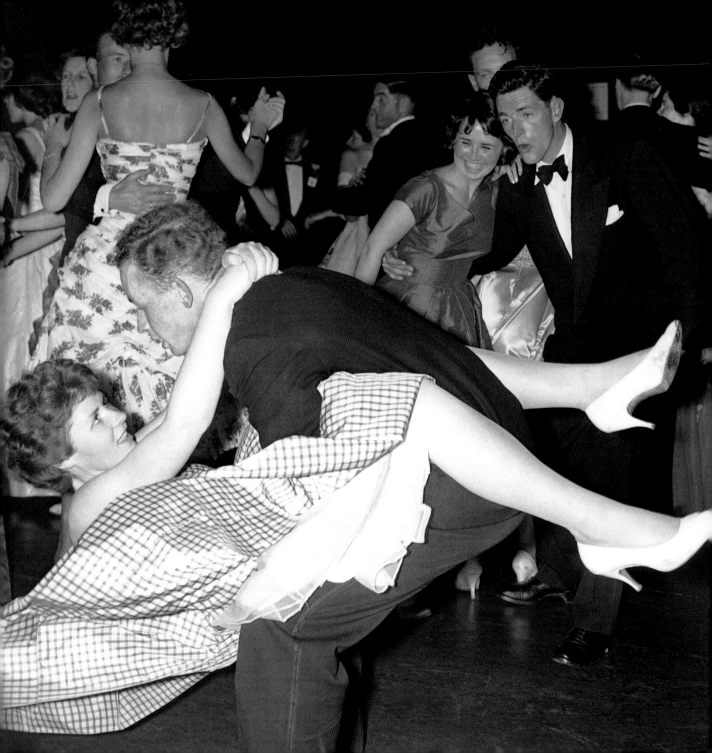

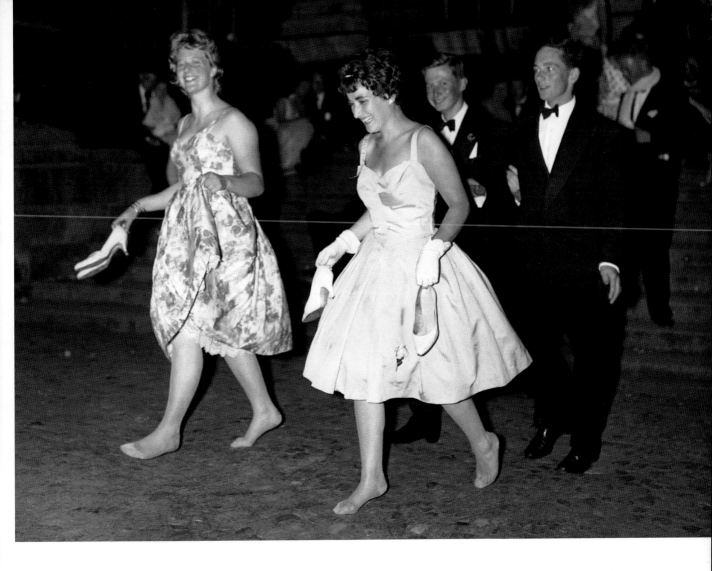

Admiration for a daring 'dip and swing' move at the
Trinity Ball. Wide skirts, 'stiff slips' and kitten heels were
the order of the day.

13 June 1959

'After the Ball was Over'. Revellers abandon fashion
for comfort on the stones of Trinity College after a
night of dancing at the Trinity Ball.

13 June 1959

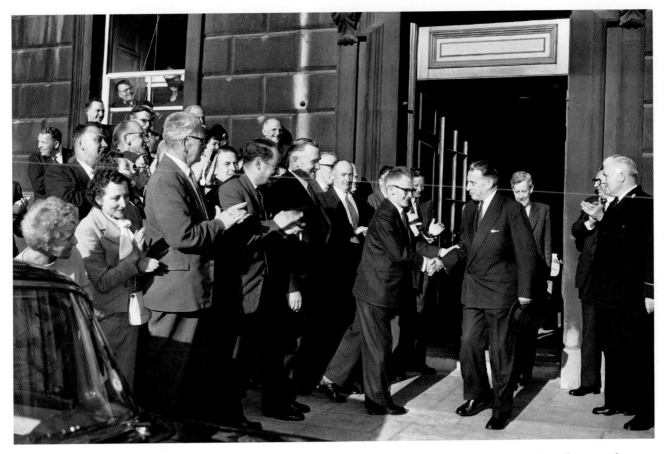

Seán Lemass is congratulated by colleagues and
supporters on his appointment as Taoiseach.

23 June 1959

Alice O'Sullivan, the first winner of the Rose of Tralee
pageant. As the Dublin Rose, she beat four other contestants:
two from the United Kingdom, one from New York and
one from Tralee. In 2009, she was one of the judges for the
fiftieth anniversary of the festival.

21 June 1959

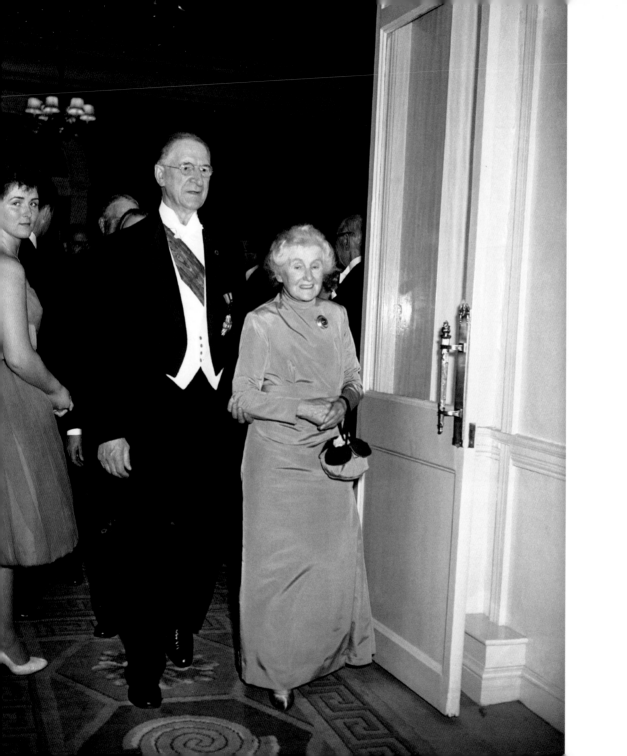

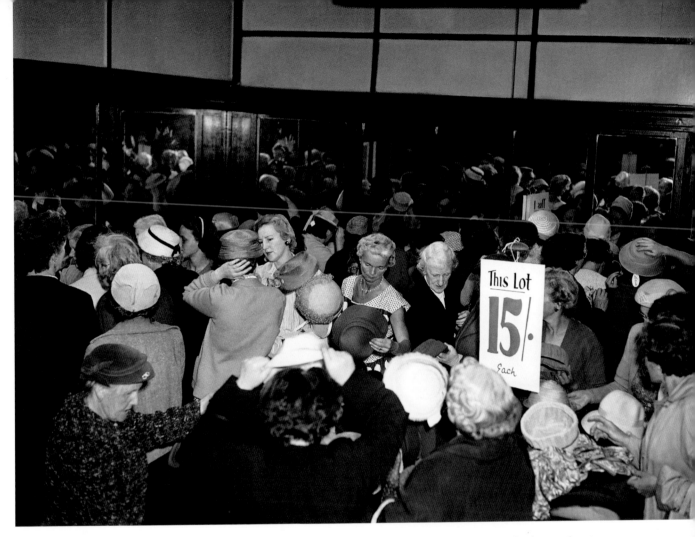

Where did you get that hat? Ladies bargain-hunting at
the opening sale of the new Dunnes Stores in Georges
Street, Dublin,

9 July 1959

Eamon de Valera and his wife, Sinead, at the ball
following his inauguration as President of Ireland.

26 June 1959

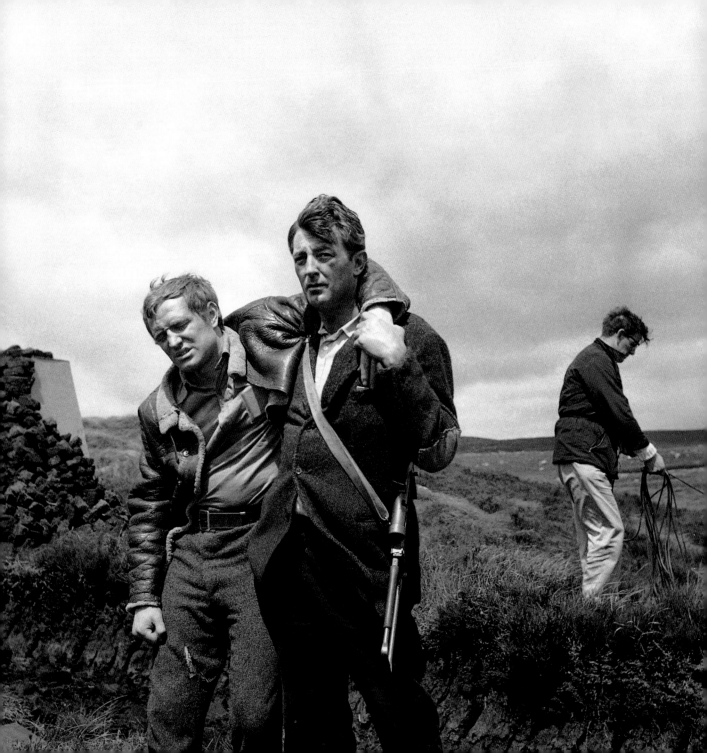

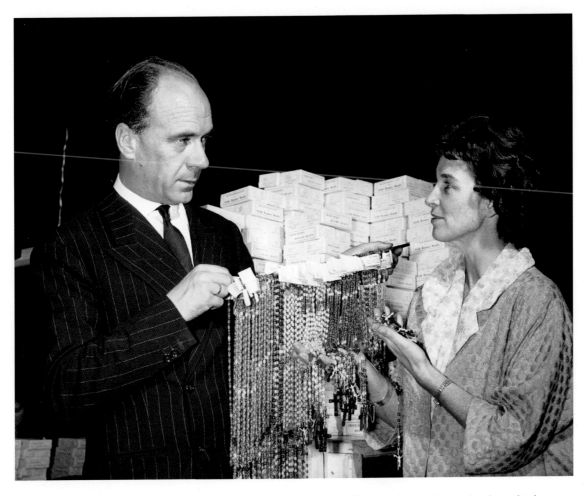

The manufacture of rosary beads was big business, both for the home market and for export. The most prized beads were made from horn, dyed in different colours. At that time saying the rosary was a nightly family activity in most households.

4 September 1959

Richard Harris (left) and Robert Mitchum filming *The Night Fighters* (aka *A Terrible Beauty*) at the Sally Gap, Co. Wicklow.

12 July 1959

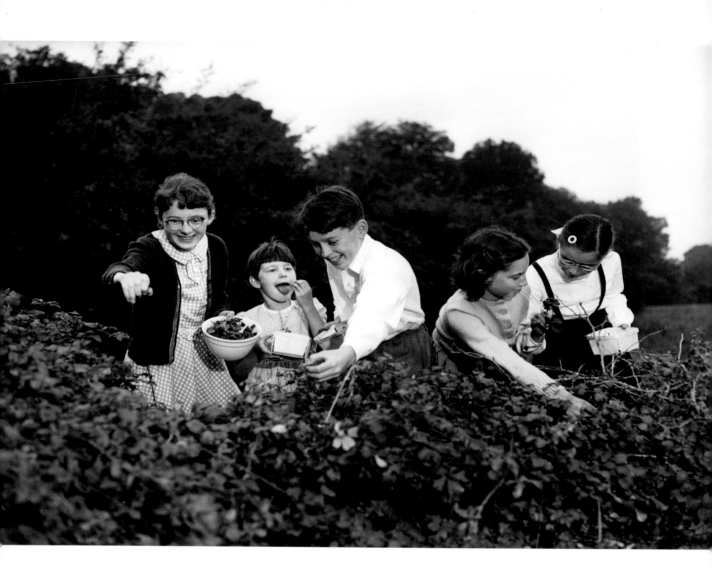

Blackberrry picking was an annual autumn outing
and every larder would have pots of the gorgeous
jam for spreading on buttered batch loaf.

19 September 1959

154

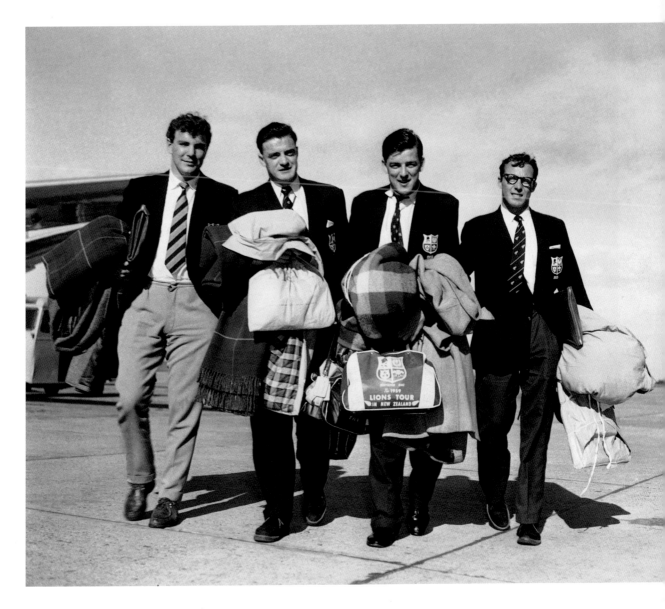

Returning members of the Lions rugby team include (l to r) Tony
O'Reilly, Bill 'Wigs' Mulcahy, Noel Murphy and Ronnie Dawson.

1 October 1959

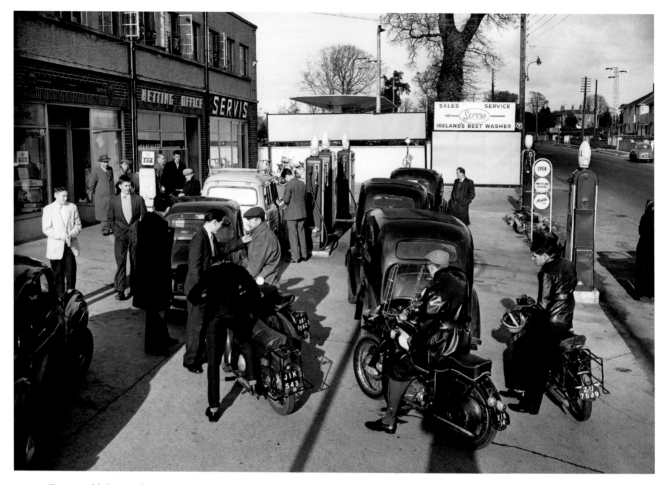

Frustrated bikers and car owners queue at a garage
during a petrol strike.

3 December 1959

Stepping into the future. The passing out
parade of the first twelve female recruits
selected to join An Garda Siochána.

4 December 1959

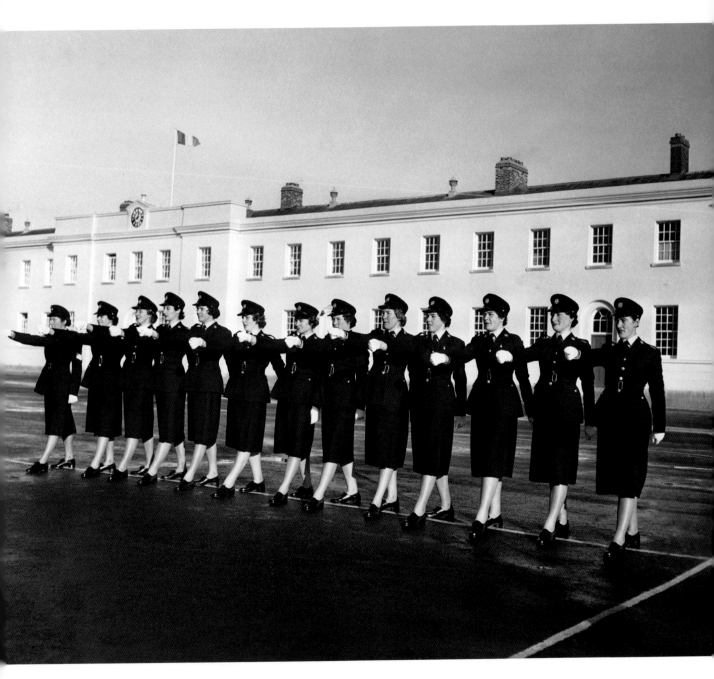

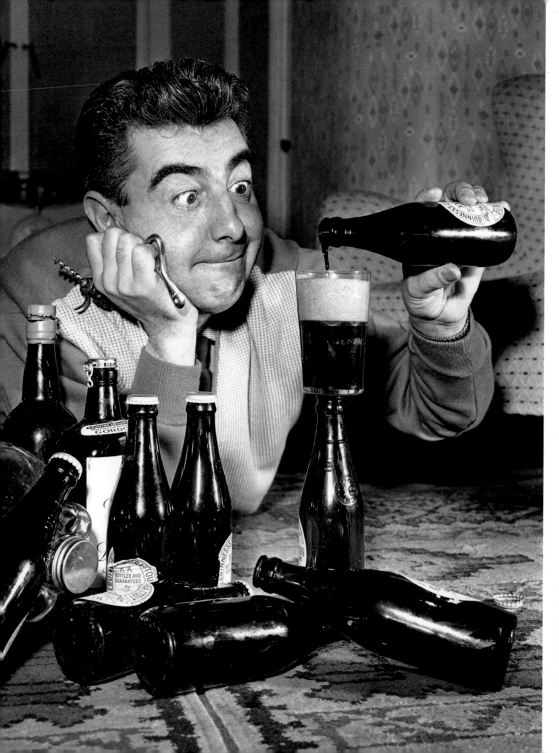

Actor Milo O'Shea gets
in a few last pints while
contemplating the dreaded
abstinence that was to come
as part of the New Year's
Resolutions.

31 December 1959

Also available

The 1960s
Ireland in Pictures

A unique collection of photographs that captures the essence of a decade of change in Irish life and will bring back memories of the people, personalities, events – big and small – that shaped the period.

Images from The 1960s

Ireland in Pictures